RUGBY
THROUGH TIME
Jacqueline Cameron

AMBERLEY PUBLISHING

Dedicated to Paul Torr, a very gifted and talented artist and writer

First published 2011

Amberley Publishing
The Hill, Stroud
Gloucestershire, GL5 4EP

www.amberley-books.com

Copyright © Jacqueline Cameron, 2011

The right of Jacqueline Cameron to be identified
as the Author of this work has been asserted in
accordance with the Copyrights, Designs and
Patents Act 1988.

ISBN 978 1 84868 607 6

British Library Cataloguing in Publication Data.
A catalogue record for this book is available from
the British Library.

Typeset in 9.5pt on 12pt Celeste.
Typesetting by Amberley Publishing.
Printed in the UK.

Introduction

In writing the *Through Time* books for Amberley Publishing, I have gained lovely insights into the heart of a town. Rugby is no exception, and although it is a place I have visited many times, I had never really got to know the town or the people who make it such an interesting place to write about until now.

As children, me and my sister would get on the train at Milverton Station with Mother on a Wednesday when the train ran its weekly service, for a ride along the line to Rugby. The train consisted of two carriages and an engine. The driver would be at the ready when we ran along the wooden platform, and the stoker would be stoking the engine ready for the journey. These would later be replaced by the old 'push-and-pull', which did not quite have the charisma of the engine, but it enabled the driver to do the return journey without uncoupling the engine. I loved these old trains with their leather window-straps and the lovely old pictures above the seats where we sat, just under the luggage rack, which was situated above the seats. As we chugged along the line, I would look at these beautiful old pictures and dream as the wheels went over the track singing 'diddly-dee' as we headed for Rugby. The train would leave at 1.38 p.m. and occasionally we would get off at Long Itchington to visit Auntie Phyllis.

Rugby, at one time, was just a small settlement that was the victim of many invasions in its early history, by the Romans, Saxons, Danes and even the Normans, who robbed the common people of their land. Although Rugby as we know it today dates back some 2,000 years, it was not until the nineteenth century that it became of some importance. Rugby football and the famous Rugby school really put Rugby on the map. Thanks mainly to William Webb Ellis, who caught the ball and ran with it, that Rugby football was founded in the town in 1823. *Tom Brown's School Days*, the famous book written by Thomas Hughes, was based on Rugby school. Gilbert's football was also manufactured in the town.

The arrival of the railway in the 1830s saw an influx of workers converge on Rugby. Businesses began to take off in a big way with, for example, the opening of the Rugby Corset Factory in 1881. Corsets were an important item in a lady's wardrobe, and I well recall, many years later, my first pair when I was a young girl of fourteen years of age; the trouble I had trying to keep up my silk stockings. Those corsets! The little piece that actually went through the stocking kept coming off and, thanks to the substitution of a three penny bit, many a young girl's blushes were saved.

The British Thomson-Houston Company, affectionately known as BTH opened its gates for business in 1902. Williams & Robinson's Electrical works, and Symington's all catered to the needs of the workers arriving in the town.

By the end of the nineteenth century, the population of the town had increased to 20,000. With the opening of the Rugby wireless station, whose masts could be seen for miles, at night the red warning lights brightened the sky.

As Rugby's popularity increased, the town began to expand, as one business after another opened its gates in the town. The Rugby Portland Cement Company, Parnells and Fosters & Dicksee were all eager to trade in the town. The Mazda lamp factory was another well known employer, as was Lodge Plugs.

To really appreciate Rugby and the importance that Rugby School has on the town, you only have to look up the High Street to the gateway that leads into the old quad at Rugby school. A window donated by Dr J. Percival, who was Headmaster of the school 1887–95, stands impressively above the gateway, with its stained glass bearing the names and portraits of successive Headmasters. The Rugby school dominates the town and covers many acres of land and occupies old buildings in the centre.

It is interesting to note that, until corporal punishment ceased in the 1960s, the Birching Tower was still in existence.

The founder of Rugby School was Lawrence Sheriff, born in Rugby in 1515. In 1567, he made a will leaving land and property for the foundation of a free grammar school for boys from Rugby and Brownsover, and four Almshouses, also to be built in Rugby. He was an interesting man who, after serving an apprenticeship to be a London grocer, supplied the household of Princess Elizabeth with 'spices and necessaries' for which he was given, among other things, a grant of arms in 1559.

The rural district of Rugby covers an area of approximately 125 square miles and on 19 October 1932 the town received its Charter and became a municipal borough. Two Roman roads pass close by the town – Watling Street and the Fosse Way – with settlements, Banjo enclosures, villas and forts that were active at this time in the area. Baginton Fort, near Coventry, is a fine example of what the fort would have looked like at that time. Standing on the borders of Leicestershire and Northamptonshire, in East Warwickshire, the town enjoys easy access to all the motorways.

Over the years, I began to travel alone to Rugby by train. Alas, the little train no longer ran from Leamington, the line being axed in the Beeching era, and I had to travel to Coventry to catch the Rugby train from there. Rugby station, before its recent modernisation programme, was a huge old station that the Euston train would travel through without stopping on the fast line. I loved my trips to Rugby, as I could visit the old market that appeared to stand on waste land in the town. You would weave your way among the stalls, avoiding muddy patches where folk had walked and the numerous puddles, unlike today's market which is held in the pedestrian-only High Street, with neither sight nor sound of mud or puddles! Having walked round Rugby market in 2011, I have to admit that the market stalls in Rugby still, as they did many years ago when I used to visit the town, sell everything from fruit and vegetables to batteries and knickers a lot cheaper than anywhere else throughout Warwickshire.

It appears from Rugby history books that the markets were not the only places selling items cheaply, as at one time the town's market centre had fifteen inns in and around the market square, all providing ale at ten pence a gallon. And as if this wasn't enough, you could also buy a bottle of Jamaica Rum for one shilling and four pence. Gin could be purchased even more cheaply, which resulted in cheap lodging houses, beggars, brawling and drunkenness. Couple this with drunken singing and yelling at one another as the bars emptied, and the town centre was not the nicest of place for respectable people to live in!

I have to say things have improved a lot since those days, but, if I am honest, Rugby still has its fair share of watering holes.

The town also has its fair share of academics, which quite surprised me as I had not, until now, given the matter a lot of thought. Thomas Hughes Q. C. M. P. the author of *Tom Brown's School Days*; Neville Chamberlain; Sir Anthony Quayle, the actor; Salmon Rushdie, author; Walter Savage Landor the poet; Charles Dodgson, who under his pen name Lewis Carroll wrote *Alice in Wonderland,* and Rupert Brooke, the famous war poet who wrote, among other things, *The Soldier.* Sadly, such a talented man as Rupert Brooke was to come to an end shortly after a septic mosquito bite on his twenty-seventh birthday.

Sir Frank Whittle also had associations with the town, and his jet engine was run on a test bed for the first time in the British Thompson-Houston factory in Rugby.

I have enjoyed my time in Rugby and thank Amberley Publishing for giving me the opportunity to write *Rugby Through Time* for you, the reader. It has left me with lovely memories of the town. One thing that really sticks out in my mind is the Storytelling Tree, on Whinfield Recreation ground. It's a gem. It is such a pity that it is so far from the town when you are walking along the Clifton Road.

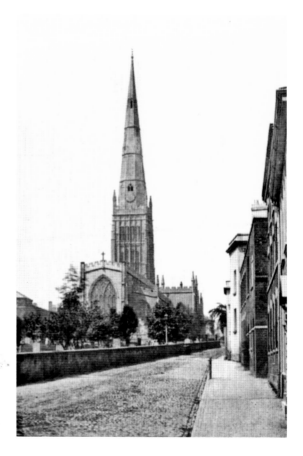

St Michael's churchyard and Holy Trinity Church taken from Priory Row, Coventry before 1870.

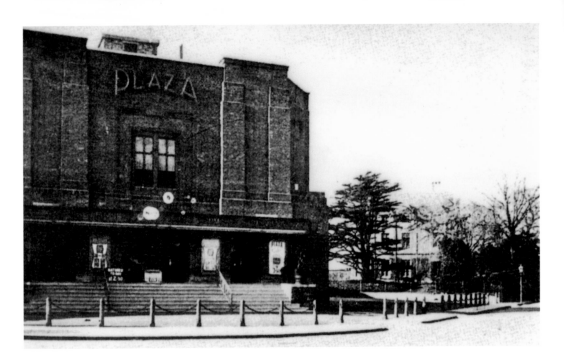

The Plaza Cinema

The Plaza cinema stands at the bottom of North Street and was opened on 30 January 1933. In 1946, it became known as 'the Granada', until the early 1970s when it closed as a cinema and became a bingo hall. Alas, the building is now boarded up and looks a sorry sight as you approach the town.

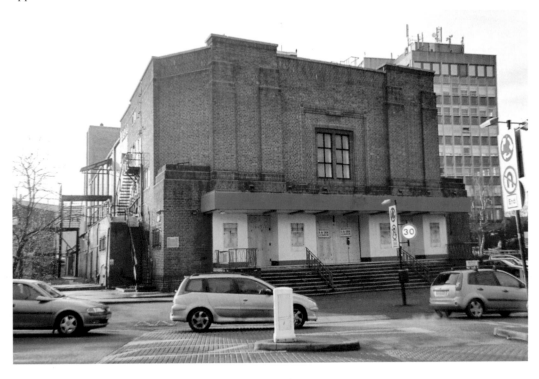

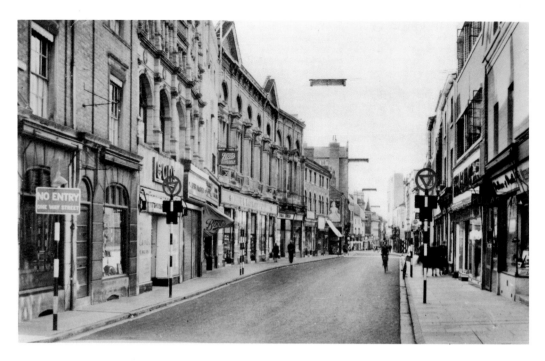

High Street

High Street has changed a great deal from the picture on the postcard (*above*). It is now shopper-friendly, and although we cannot see them on the photograph below, the planners have trees, reproduction lampposts, and benches to rest on in the town centre. Although cars can drive down this particular street, most of the centre of the town is now pedestrianised, and there are raised flower beds to add to its charisma.

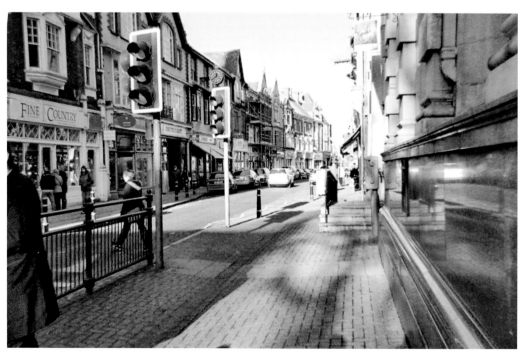

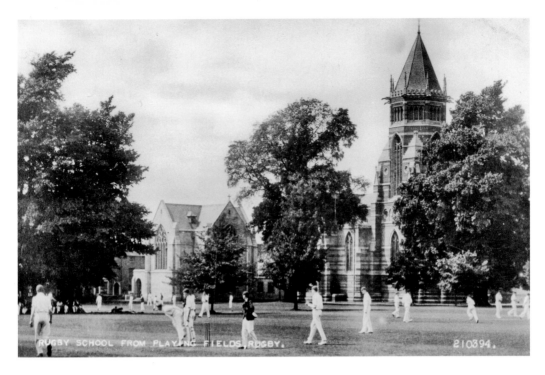

RUGBY SCHOOL FROM PLAYING FIELDS, RUGBY. 210394.

The Playing Field
There are no two ways of looking at the grounds of Rugby school. They are big, well-maintained and a pleasure to walk round. Obviously there is plenty of evidence of rugby posts, but skirting the perimeter are the lovely old buildings of the school itself, and to me they are a fine example of a bygone era and a pleasure to visit.

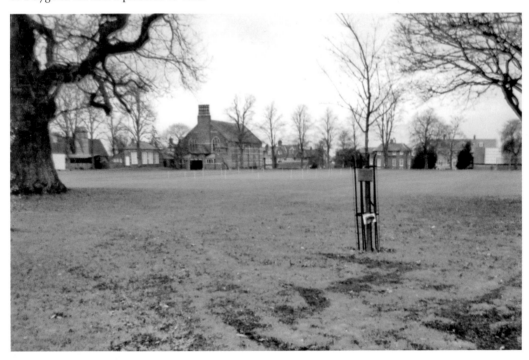

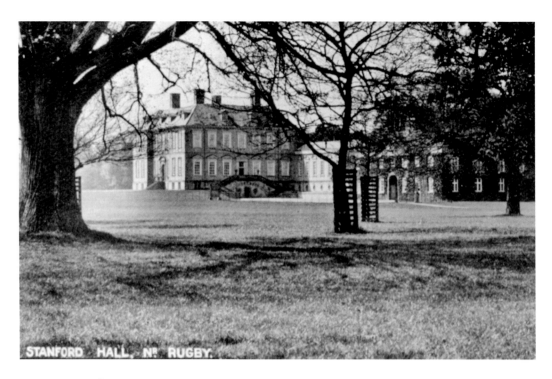

STANFORD HALL, Nʳ RUGBY.

Houses of Note
I have included these houses as they reflect the grandeur of Rugby and its surrounding areas.
Pictured are Stanford Hall (*above*) and Castle Ashby, near Northampton (*below*).

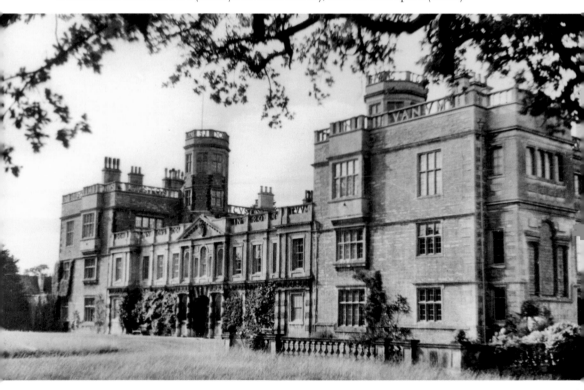

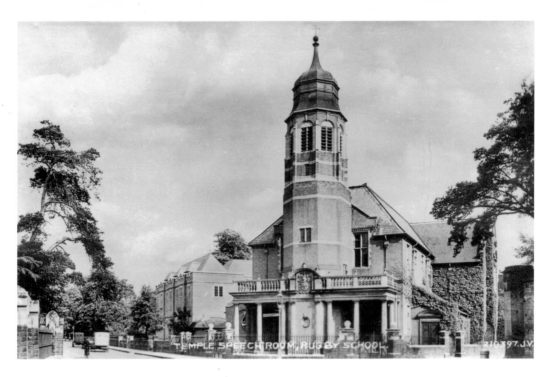

Speech Room

This beautiful old building is the Temple Speech Room at Rugby School. When I took the photograph below, the school orchestra was playing a delightful piece of classical music, filling the air with peace and tranquillity. It quite made my day.

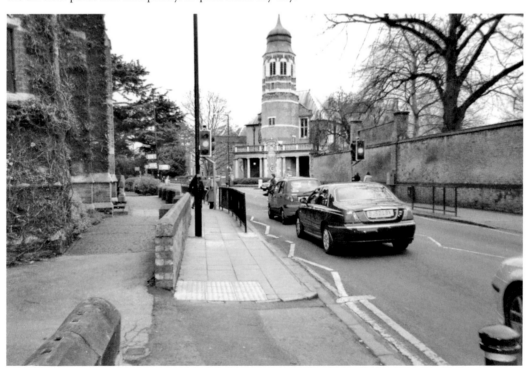

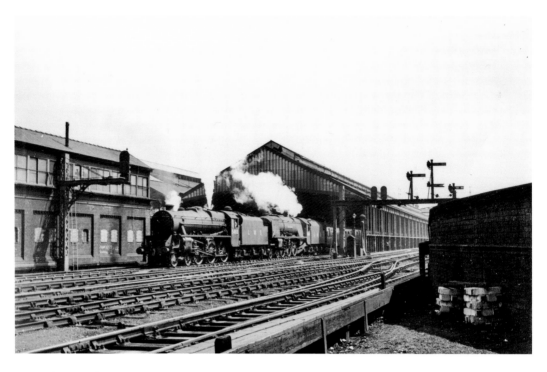

Sherwood Forrester

Taken in May 1939, we see the 6112 *Sherwood Forester* express arriving at Rugby Station (*above*). The bottom photograph shows the *City of Chester* in Rugby Station 5493 – 6239. Taken in 1948, we have moved forward in time but the engines have not changed a great deal.

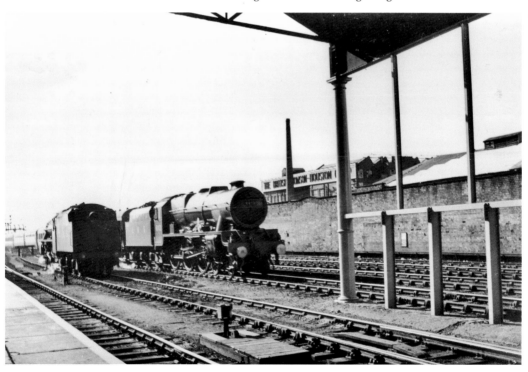

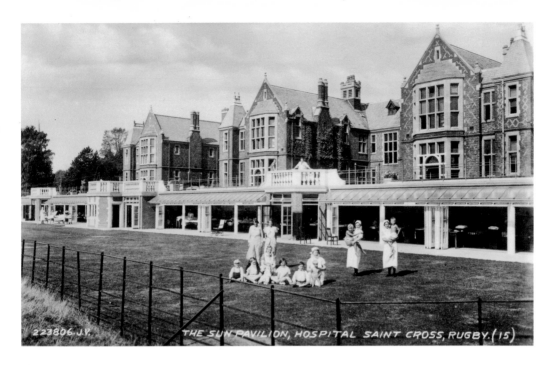

223806.J.Y. THE SUN PAVILION, HOSPITAL SAINT CROSS, RUGBY. (15)

The Sun Terrace

This lovely old photograph shows the Sun Pavilion, with its sliding doors, at the Hospital of St Cross. HRH Princess Royal Mary opened the Pavilion on 8 October 1932. Beds were pulled out into the sunshine on the Terrace. Since its completion in 1884, the hospital has been modernised and extended over the years. It is thanks to the generosity of R. H. Wood and his wife, who lived in Rugby, that the money and land was donated to the town.

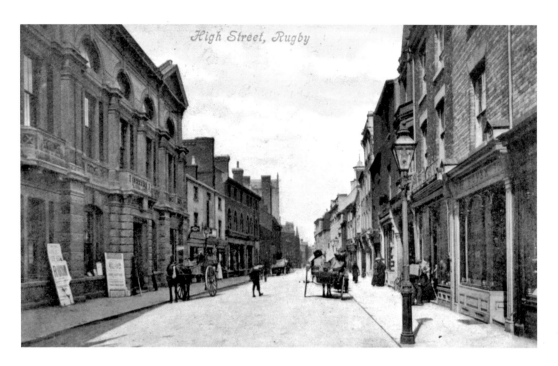

The Old Town Hall

In the top postcard, we see the town hall on the left, which was built on the site of the old Elborow School and Almshouses in the seventeenth century. In the 1900s, the civic facility was moved to the Benn Building. Now a pedestrianised town centre, the bottom picture still captures the tranquillity of that bygone era.

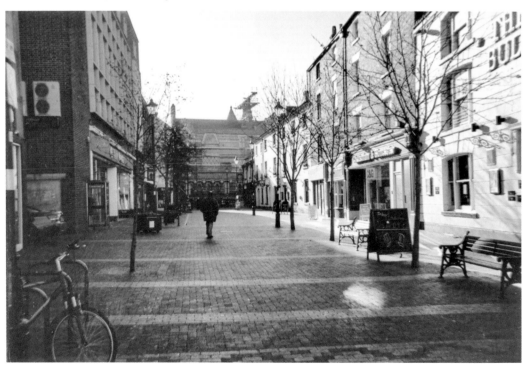

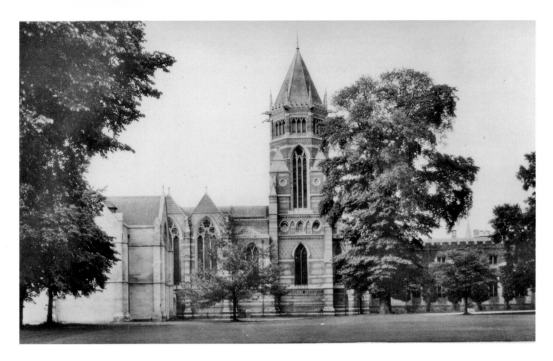

The Chapel

An unusual feature of the school chapel was its original flat plaster ceiling, divided into squares by thin beams. Dr Thomas Arnold became Headmaster in 1829, having succeeded Dr John Wooll. Unlike Dr Wooll, Dr Arnold hated the roof, where each square was divided into four triangles with an elaborate wooden boss at each intersection. He would, however, have approved of its replacement in 1852 – an open timbered ceiling.

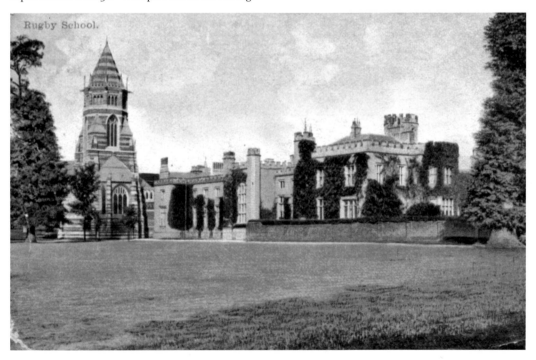

Rugby School.

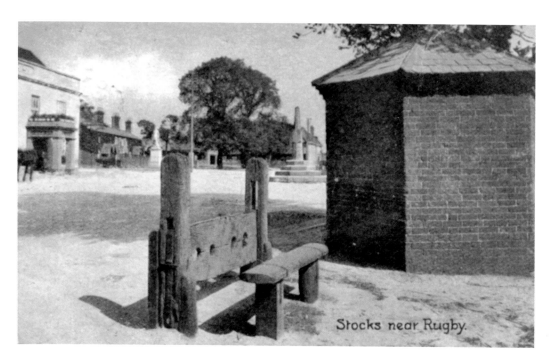

Stocks near Rugby.

The Stocks at Dunchurch

Unlike the stocks I photographed in Berkswell for *Coventry Through Time*, the ones in Dunchurch only have four foot holes and not five! Although the bench is no longer there, the stocks are, as a constant reminder of the 'naughty goings-on' in times past.

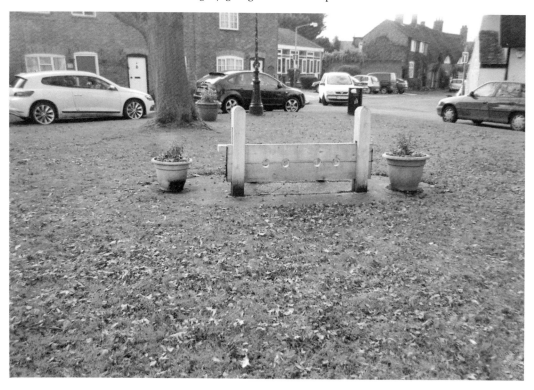

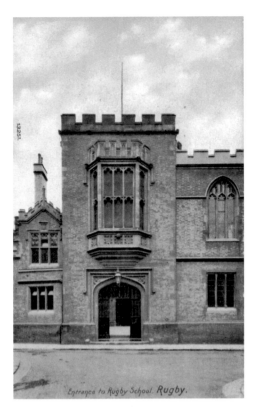

Entrance to Rugby School. Rugby.

The School Entrance
Two contrasting views of the entrance to Rugby School. It is interesting to observe that the door is still open, welcoming people into the school quad in the present day. Standing at the end of the main pedestrian walkway, it makes a lovely centre piece as you do your shopping or just take a stroll in the town. The man on the right is Mr Bob Jones, who is doing just that!

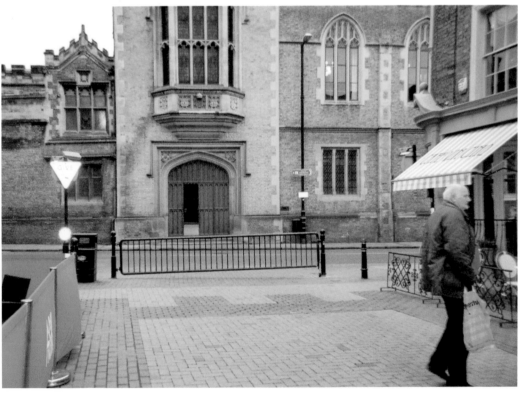

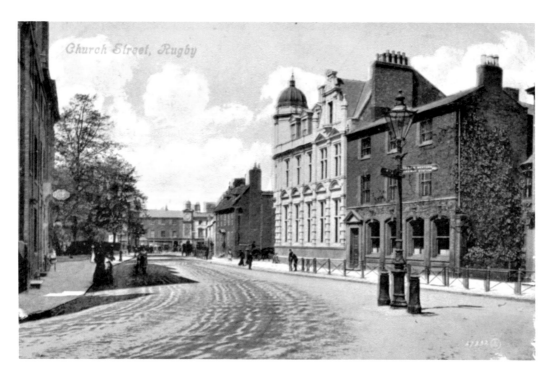

Church Street

Here we see Church Street, which stretches from St Andrews Church to Clifton Road. The white building in the centre of the postcard is Lloyds TSB bank. The building to the right has been replaced with a modern HSBC Bank.

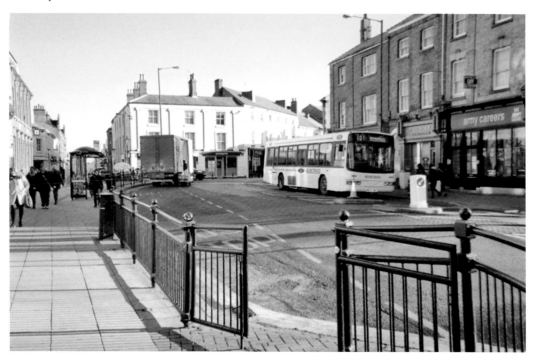

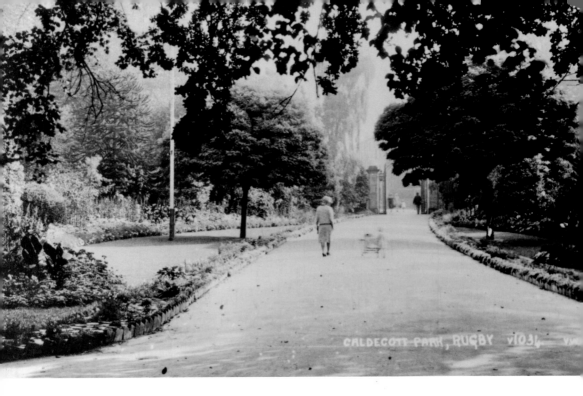

Caldecott Park

This tranquil scene of Caldecott Park was taken before the park underwent a facelift. The trees, the natural beauty, the peaceful setting; the park was a pleasure to visit.

I love this old postcard of the River Avon at Stratford Upon Avon because not only is it in colour but it gives a view of the road that runs beside it.

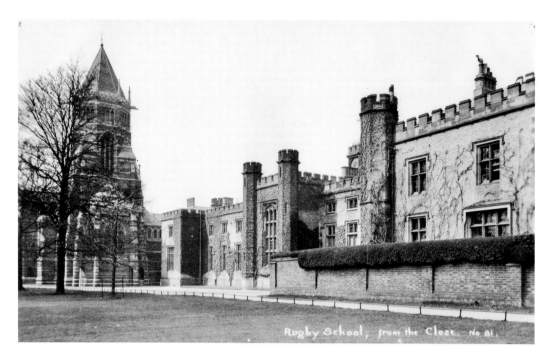

Rugby School, from the Close. No 81.

Rugby School

Rugby's main 'claim to fame' has to be Rugby School and its association with the game of Rugby football, which was founded in 1823 by William Webb Ellis, who, it is reputed, caught the ball and ran with it. The magnificent buildings of the school dominate the town centre, and no matter which road you travel down you will come upon one of these lovely old buildings.

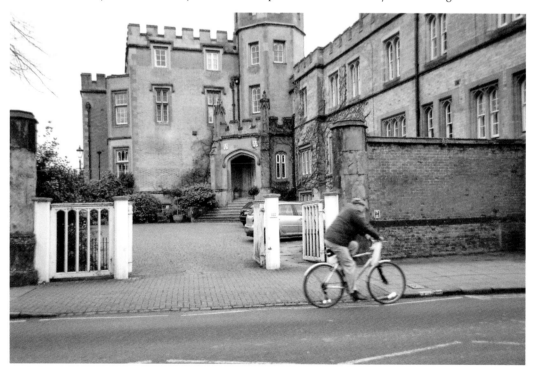

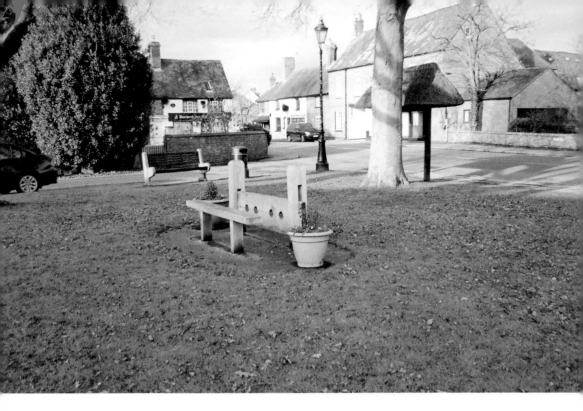

The Dun Cow

Above, these old stocks can be found on the square at Dunchurch, two miles south-west of Rugby. In the top picture, on the left, is the Dun Cow, a very popular eating house if the packed car park is anything to go by. Below, taken in 1935 from Iron Monger Row we see the Bull Ring and Butcher Row. Sadly the houses were demolished to make way for Trinity Street, Coventry.

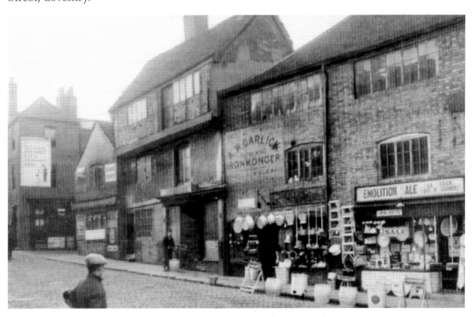

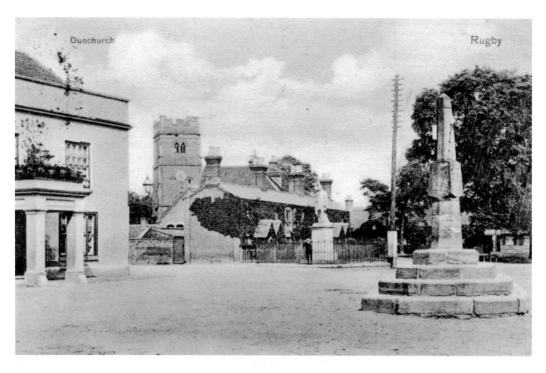

The Village Cross

The cross has a tapered shaft with an inscription stating that it was erected in 1813 as a milestone. It is believed that the base probably belonged to an earlier cross. Sadly, time has taken its toll and it is difficult to imagine that the monument is a cross at all.

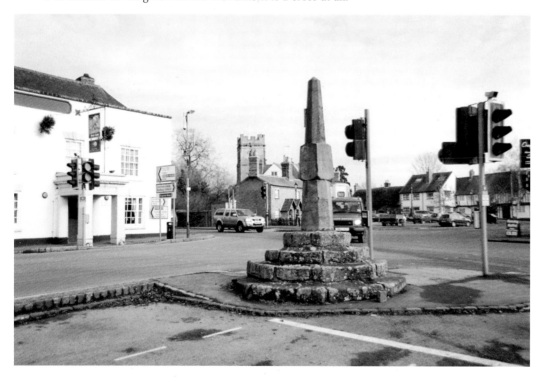

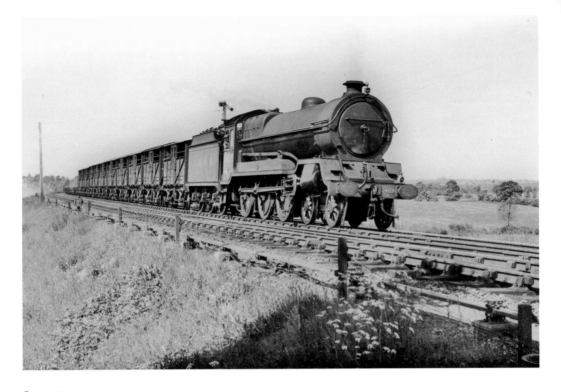

Staverton

Here we have two magnificent views of locomotives for the train buffs. The top postcard shows the 5469 with freight at Staverton Road, near Rugby, in June 1939. While the bottom postcard the 3796, also freight again, is seen at Staverton Road, 1946.

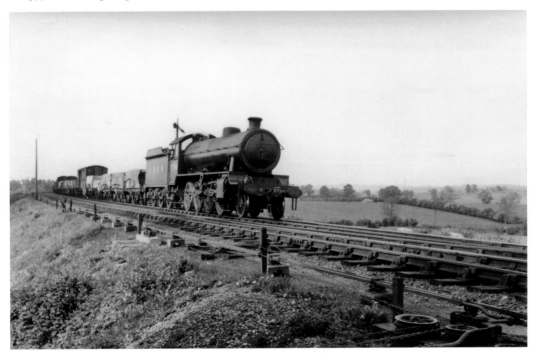

St Marie's Church

Rugby's first Catholic church, with its 200-foot spire was designed by Mr B. Wheelan of London, in the early Gothic style of the fourteenth century. Standing on Dunchurch Road, the small Norman-style tower contains a peal of eight large bells. In 1862, the church was enlarged, with a spacious nave replacing the original aisle and the Lady Chapel. The church is renowned for its beautiful stained glass windows, many of which were made by John Hardman of Birmingham. However, the Mayor of Munich made two splendid windows for the church. I have always loved stained glass windows and I had a friend who used to travel round the country drawing each stained glass window and recording it.

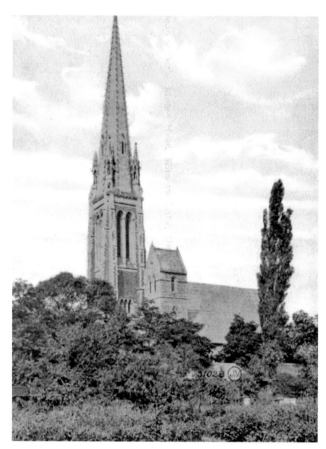

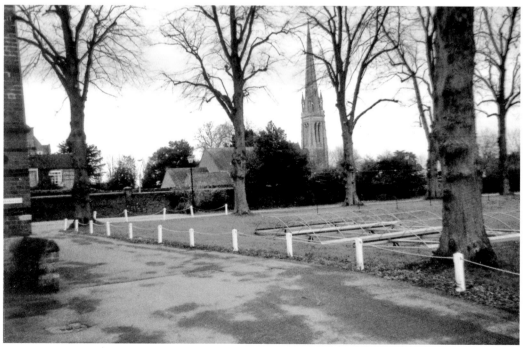

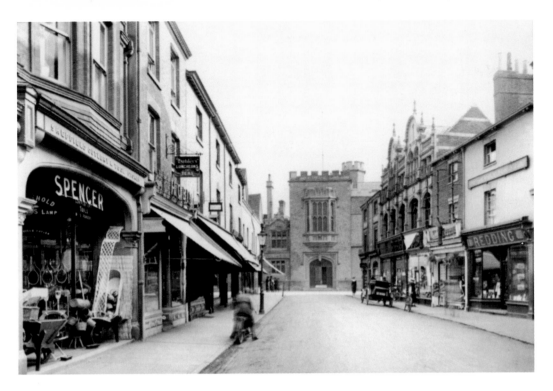

The Gateway

Standing at the top of the main street is the Rugby School gateway. It makes an impressive sight as you make your way through town. The bottom photograph shows the restaurant, which stands on the right-hand side of the gateway, more or less where the old car is standing in the top postcard.

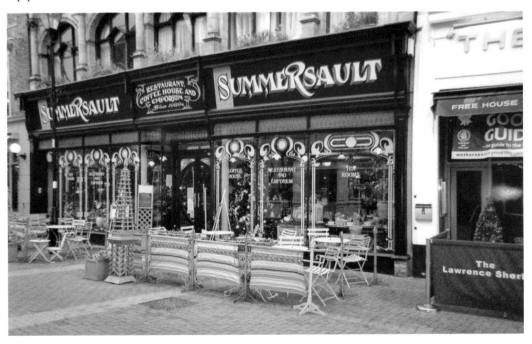

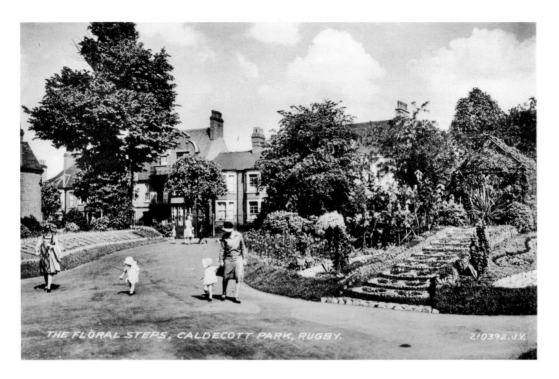

THE FLORAL STEPS, CALDECOTT PARK, RUGBY. 210392.J.V.

Caldecott Park

Situated at the heart of the town, Caldecott Park was completely restored to its former glory in May 2009, thanks to the Heritage Lottery Fund. The Floral Steps, which once stood inside the Park Road entrance, have now been replaced by a modern water feature, with shrubs either side of the steps and a waterfall. But for my money, it holds none of the charisma the original steps held for me.

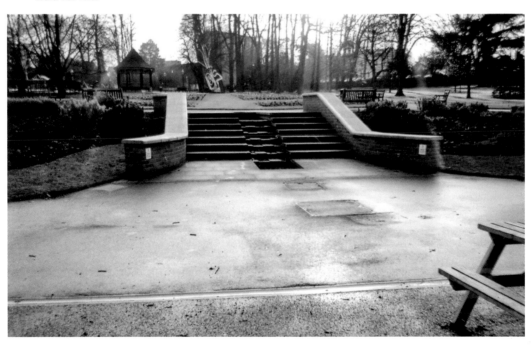

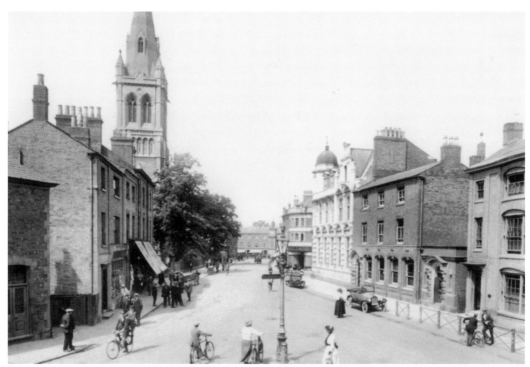

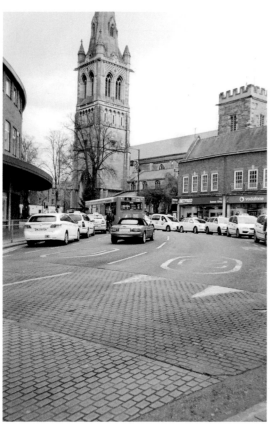

St Andrews Church

The parish church of St Andrews was rebuilt in 1879, from the designs of Mr W. Butterfield FSA, at a cost of over £35,000. The original building dated back to the late thirteenth century. The church registers date from 1620 and the list of vicars dates back to 1253.

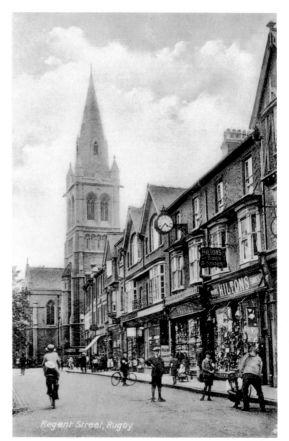

Regent Street, Rugby.

Regent Street

Overlooking Regent Street is St Andrews Church. Regent Street was created in 1902, but unfortunately a large Regency building with Gothic doorways met its demise, so that the street could be developed. A Lloyds TSB was built on the corner of Regent Street in 1906. If you like shops, you will love Regent Street as it is full of boutiques. At the bottom of the street is the Jubilee Gardens.

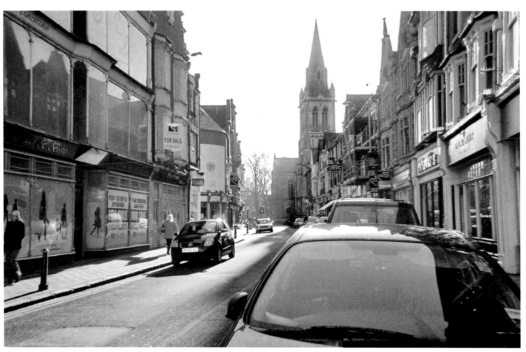

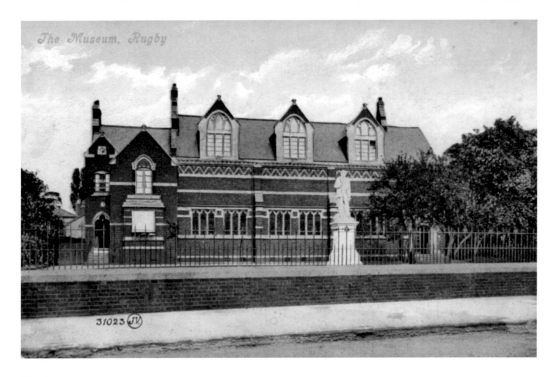

The Museums

The top picture shows the Rugby School Museum looking very much today as it always has. In contrast, the bottom photograph shows the town's state-of-the-art museum, art gallery and public library. The town's tourist information office is also housed in the building.

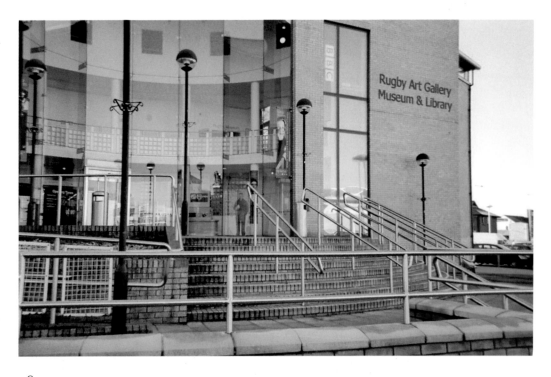

St Marks Church

1½ miles south-west of Rugby stands the charming church of St Mark, Bilton. The church tower has canopied niches at the angles and buttresses just below the parapet. From 1875 until 1889, the church underwent a lot of restoration and during this period a north aisle was added. The oak organ case in the church is said to have come from the old chapel of St John's College, Cambridge.

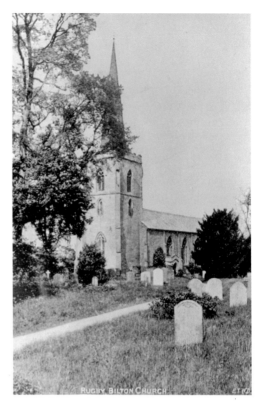

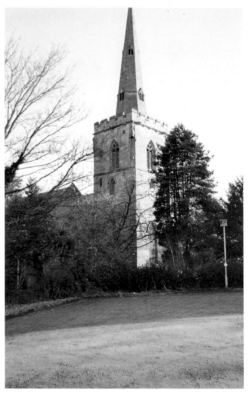

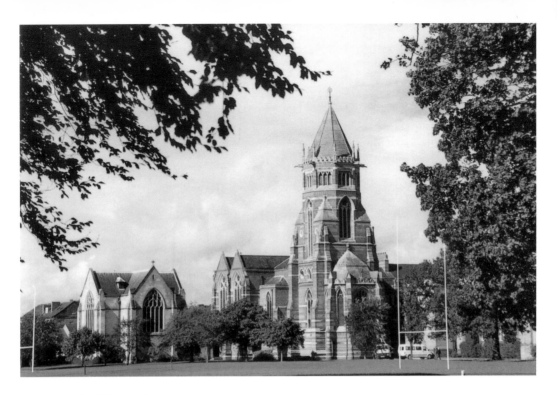

Lawrence Sheriff School
The school was opened in 1879 as a separate free school for local boys, and was the result of a proposal by Dr Temple in 1864. Built in mock-Tudor style and as a tribute to Lawrence Sheriff, a statue dressed in the livery of the Grocers' Company stands above the door. Here we see the school chapel.

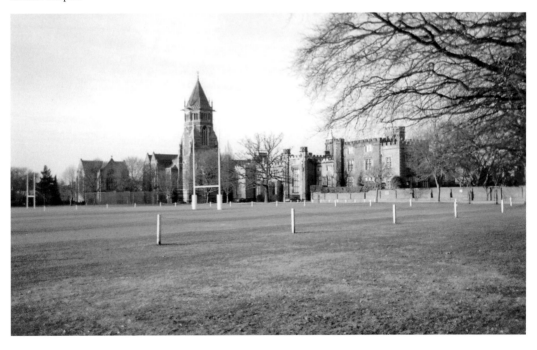

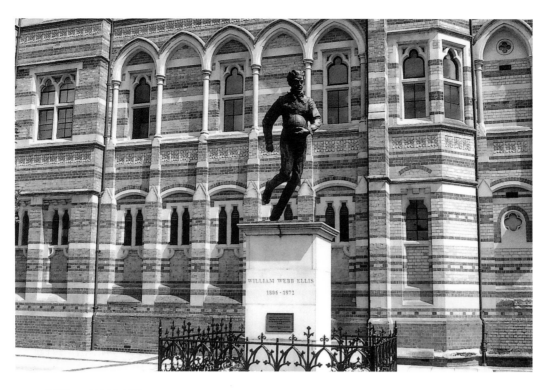

William Webb Ellis

A pupil of Rugby School, William Webb Ellis is credited with inventing the game of Rugby on the Close in 1823. Standing in the centre of the town, outside the famous school, his statue is a constant reminder of the town's achievement in the world of sport.

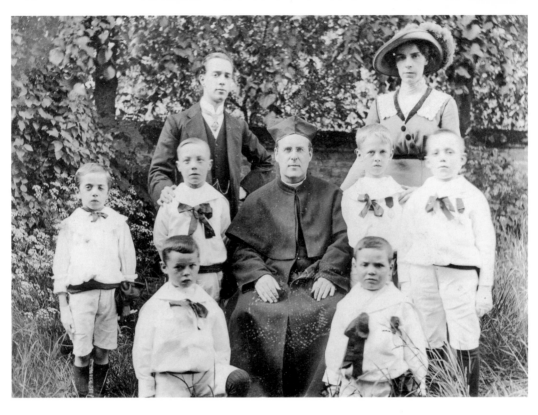

St Marie's School
This delightful photograph, taken in May 1913, shows the children of St Marie's school Rugby. The man sitting down in the centre is H. V. Fazakerley, Headmaster.

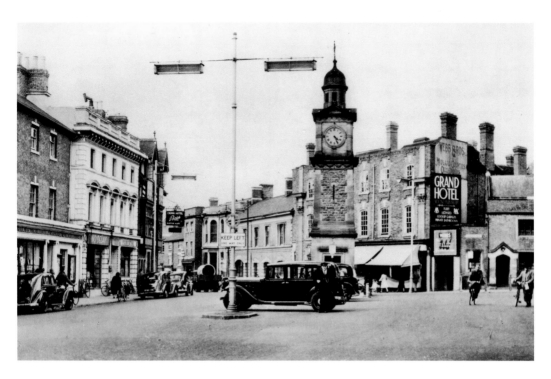

The Clock Tower

In 1932, the clock tower was the centrepiece of a large paved area used for parking. However, by the 1990s it had become part of a pedestrian shopping area. A plaque on the clock tower commemorates Queen Victoria's Golden Jubilee.

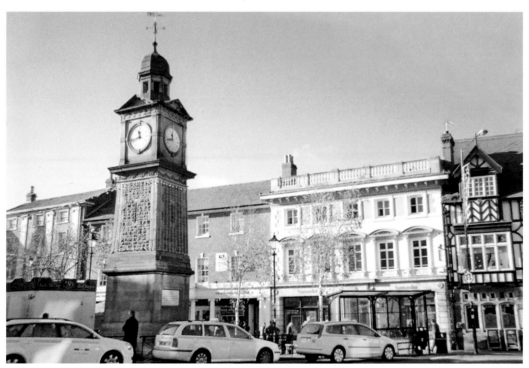

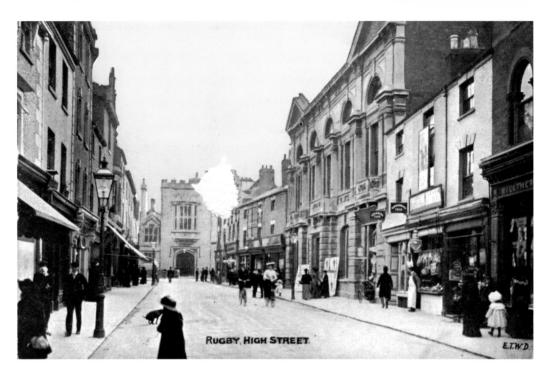

RUGBY, HIGH STREET. E.T.W.D.

Through Time

The message on the back of the postcard reads 'a great day. I particularly like this; I bought it for you while I was waiting for my train at Rugby Station'. The card was dated early 1900s. In contrast, the bottom photograph shows the same street in 2011 after it had been modernised.

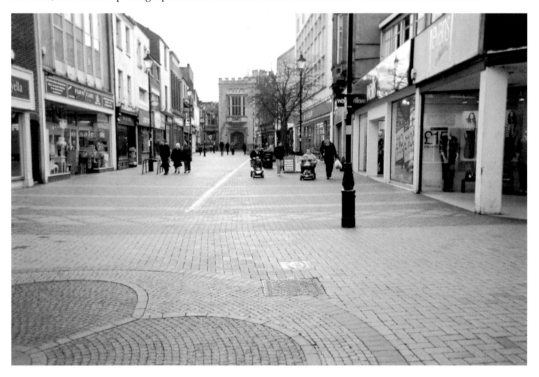

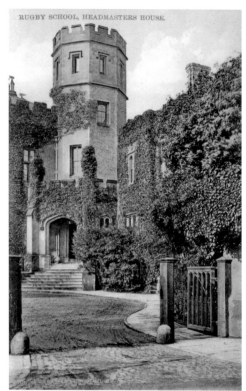

The Headmaster's House

Traditionally, the first boarders stayed in the School House with the Headmaster. The Headmaster was always known as the Housemaster of School House, and his private rooms became known as the Headmaster's House.

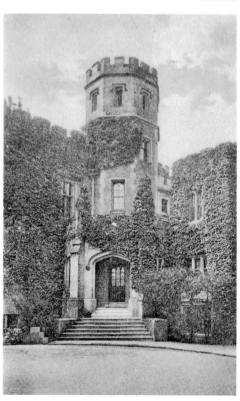

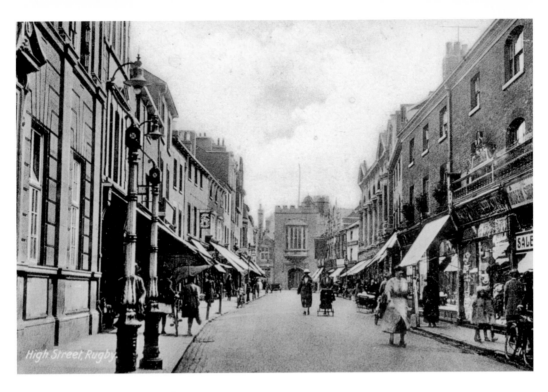

The Entrance to Rugby School

The impressive entrance to Rugby school overshadows the town. Whenever I pass the entrance, the door is open and inviting.

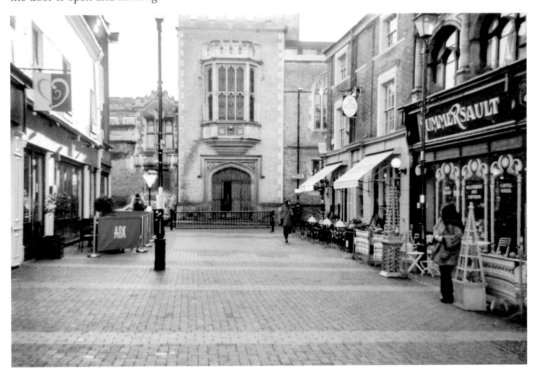

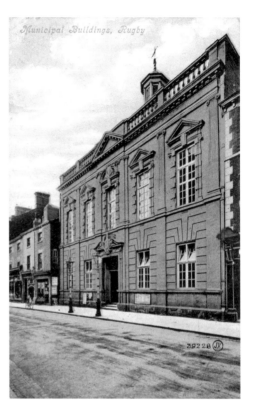

The Benn Building

In 1895, the Benn building was bequeathed to the town of Rugby by Mr C. G. Benn, for use as the town hall. Situated in the middle of the town, the building functioned as a town hall until 1936. The current town hall was built on the Lawn Estate in 1961. The Benn Building is now Marks & Spencer.

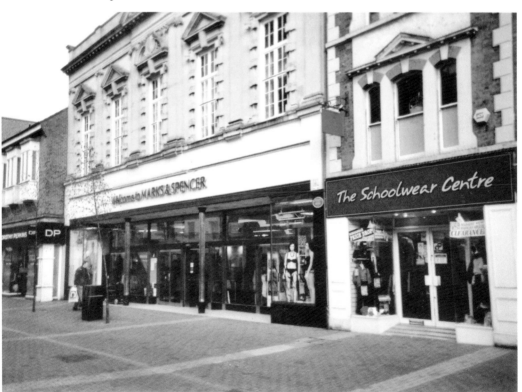

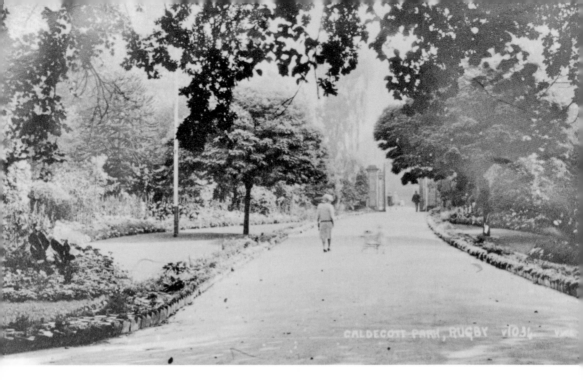

Caldecote Park

For such a lovely park, Caldecote Park's main entrance is unimpressive and its beauty is lost to the civic buildings that stand adjacent. It is also flanked by a busy main road. However, once you pass through the gates, a peaceful world awaits you.

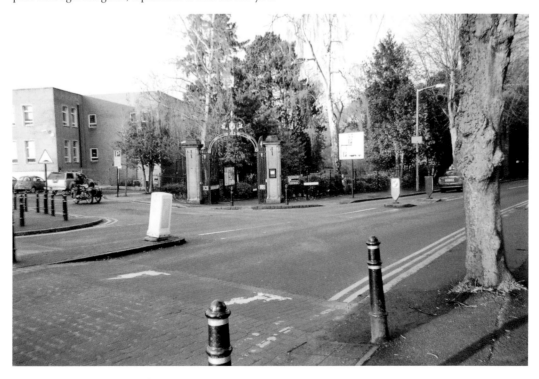

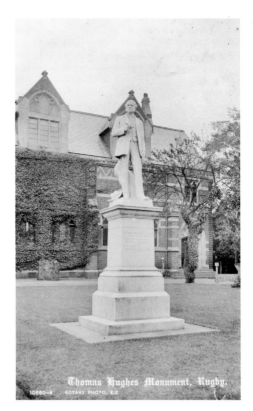

Thomas Hughes Monument, Rugby.

Thomas Hughes

Unveiled in 1899, by Edward Benson, Archbishop of Canterbury, the Thomas Hughes statue stands outside the Temple Reading Room. Thomas Hughes QCMP was the author of *Tom Brown's School Days.*

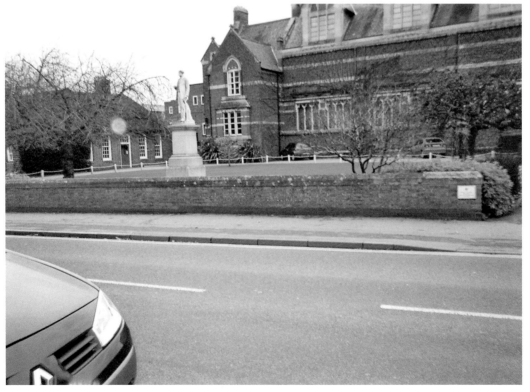

Parker Brooke
The top photograph shows 5 Hillmorton Road, Rugby, where the poet Rupert Brooke was born. The bottom photograph, taken in 1905, shows Rupert's father, Parker Brooke, who was House Master of the School Field House, at Rugby School.

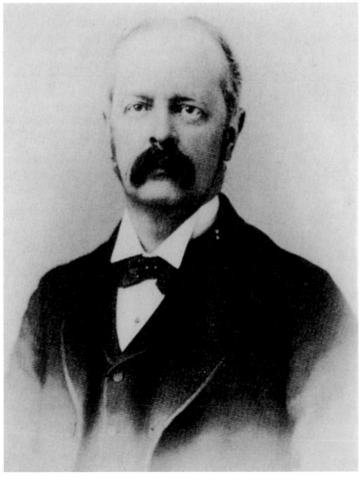

Rupert Brooke 1887–1915

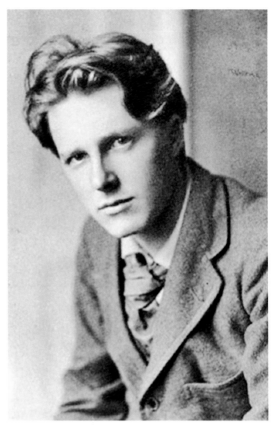

Born at 5 Hillmorton Road, Rugby, Rupert Brooke was a pupil of Rugby School. He began writing poetry at a very early age and won two prizes at school for *The Pyramids* (1904) and *The Bastille* (1905). From Rugby, he went on to King's College, Cambridge, where he was best known for his *Sonnets* in 1914. His statue stands on a plinth with a plaque which reads 'If I should die think only this of me that there is some corner of a foreign field that is forever England'. The statue stands in the Jubilee Gardens. Alas, he died from a septic mosquito bite at the age of twenty-seven, in the Aegean on the way to join the Gallipoli campaign, and is buried on the island of Skyros. The statue was unveiled in September 1988 by Dr Mary Archer.

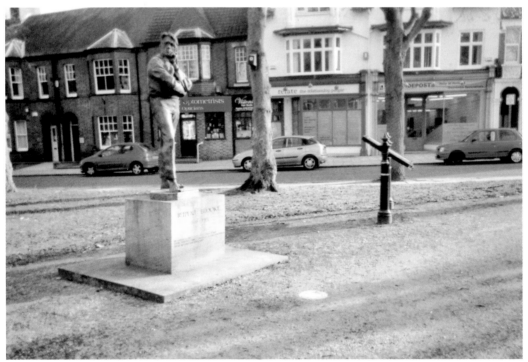

The Chapel

In 1814, with a budget of £800, the school Trustees chose Hakewell to design the chapel, which was built in the thirteenth-century style. There are also some Tudor features added to the building.

Art, Music & Literature
Thomas Arnold
Matthew Arnold
Sir Arthur Bliss
Rupert Brooke
Arthur Hugh Clough
Charles Lutwidge Dodgson
T. H. Green (Philosopher)
Thomas Hughes
Walter Savage Landor
Wyndham Lewis
John Gillespie Magee
Sir Sydney Nicholson
Arthur Ransome
Salman Rushdie
R. H. Tawney

Science
Sir John Badenoch
Professor Vero Wynne-Edwards
Stage, Screen & Sport
William Webb Ellis
Thomas Macready
Sir Anthony Quayle

Religion
Archbishop Tait
Archbishop Frederick Temple
Archbishop William Temple

Politics
Austen Chamberlain
Neville Chamberlain
R. A. Cross
Goschen
Edward Stanley
Lord Strauss
Lord Waddington

Rugby School Hall of Fame

I have included the names from this plaque as so much of the town's history is wrapped around Rugby School and the achievements of its pupils.

Features of Rugby

No account of Rugby would be complete without a mention of master craftsman John Batchelor, who for forty years made more than 60,000 rugby footballs at the James Gilbert Rugby Football Museum. In the early 1980s, he made rugby balls for the pupils of Harris Church of England high school. To commemorate this achievement, he was presented with a portrait. Below, the Rugby cattle market in Railway Terrace was one of the biggest and most important in the Midlands. Cattle were driven to the market through the town, a practice that was to continue until just after the Second World War.

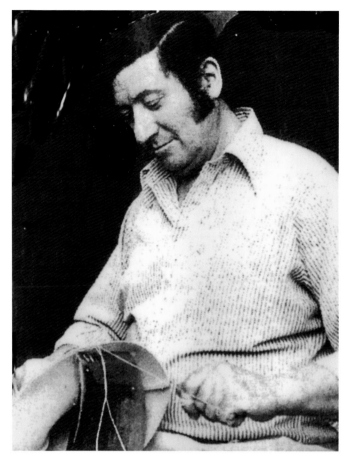

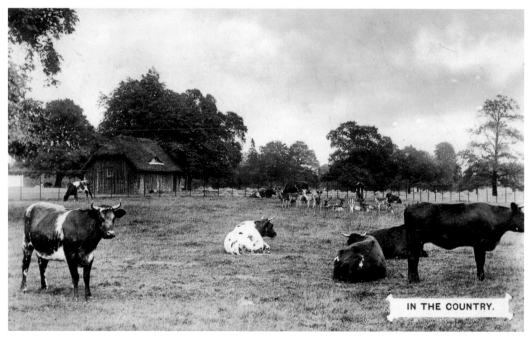

IN THE COUNTRY.

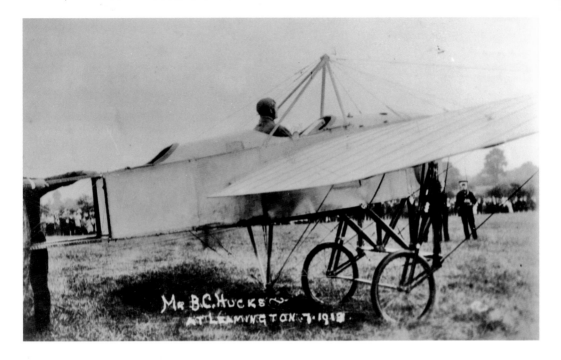

Mr B.C.HUCKS
AT LEAMINGTON 7·1913·

Sir John Whittle

How times change! This postcard dates back to 1913, and recaptures the thrills and excitement of the single flight in the pioneer days of the aircraft. One enthusiast was Mr B. C. Hucks, seen here demonstrating his skills in this field. The bronze sculpture in the photograph was designed by Stephen Broadbent, and reflects the speed and energy of Sir Frank Whittle. On 12 April 1937, the world's first jet engine was run on a test bed in the British Thompson-Houston Factory in Rugby.

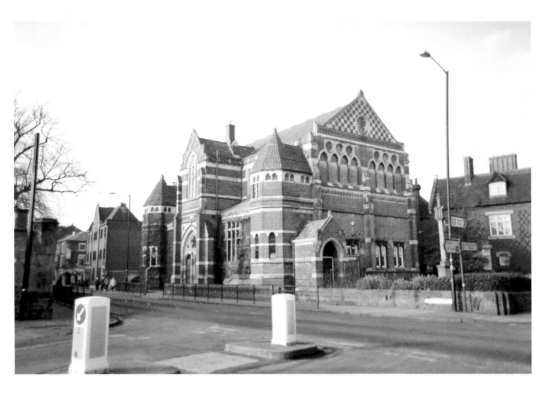

Rugby School
The town is full of delightful buildings, and these are just two examples of the extent to which the school has expanded, as both of them are annexed to the main school complex.

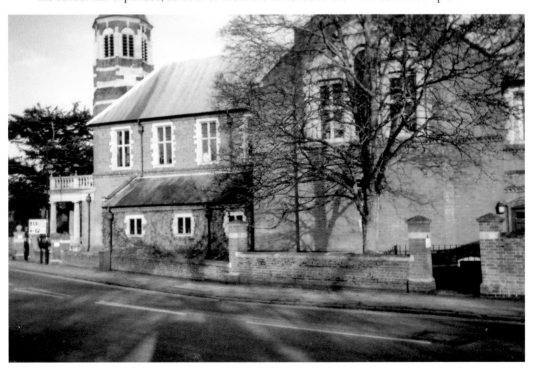

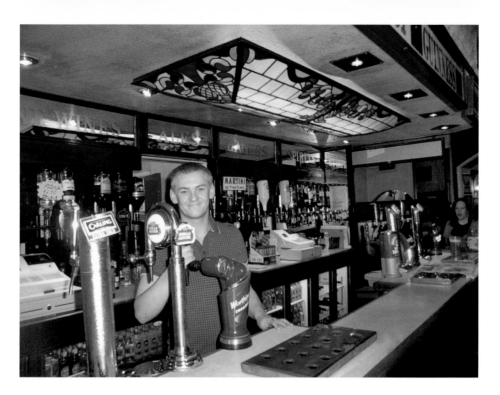

Michael Preston

Here we see Mr Michael Preston, the relief Manager at the Crown when I was taking photographs. I have included this picture, a perfect example of through time, as Michael and his wife Jess are expecting their first baby in April.

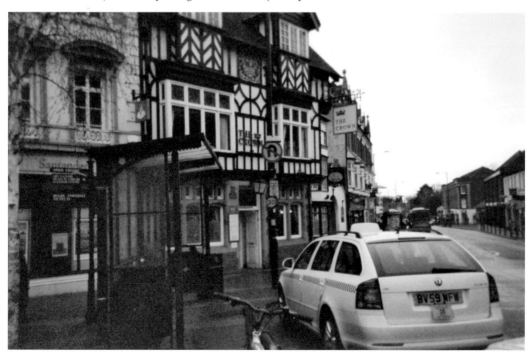

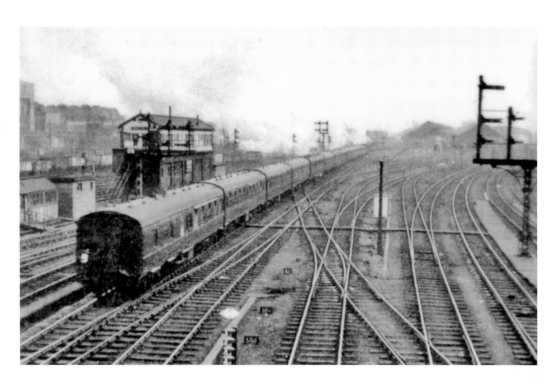

Rugby Junction

In the top picture, we see a southbound steam-hauled express approaching Rugby Railway Station. In contrast, the photograph below is the same shot taken in 2011. This time it is the Coventry–Euston train entering a newly revamped Rugby Station.

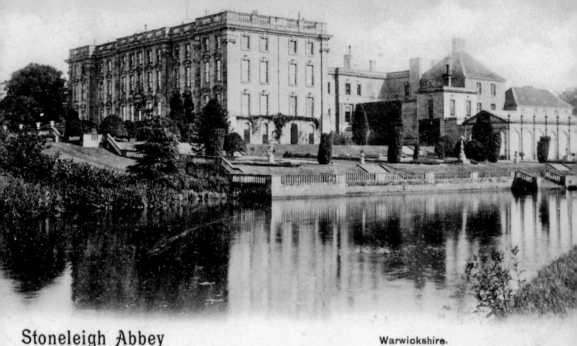

Stoneleigh Abbey

Warwickshire.

Around and About

A delightful picture of Kenilworth Castle in contrast with Stoneleigh Abbey, just two of the many historic buildings in and around Rugby.

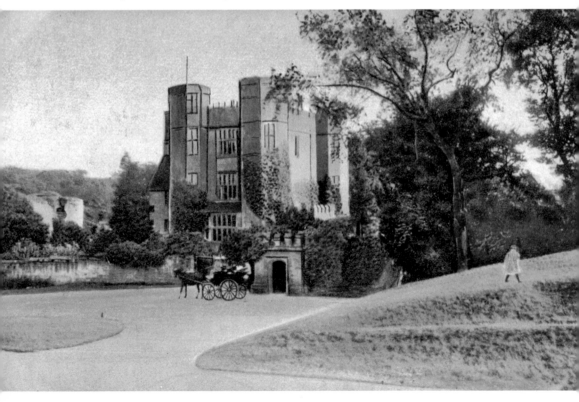

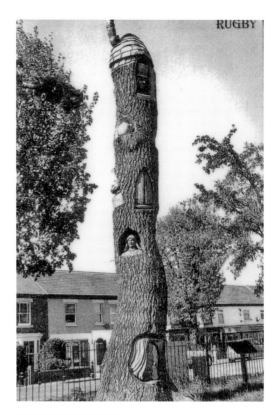

The Storytelling Tree

To celebrate the 175th birthday of Lewis Carroll, Andrew Frost created the Storytelling Tree from the trunk of an ash tree, and Rugby entered it in the National Britain in Bloom Competition. Educated at Rugby School 1845–49, Lewis Carroll was famous for writing *Alice in Wonderland*, and all the characters from the novel are carved into the tree trunk. Around the tree, which stands in Whinfield recreation ground in Clifton Road, are stacks of books where children can sit and relive Alice's adventures. Lewis Carroll – real name Charles Dodgson – is another example of the many academics of Rugby School.

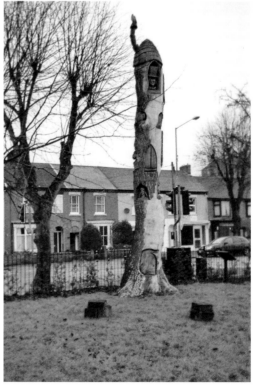

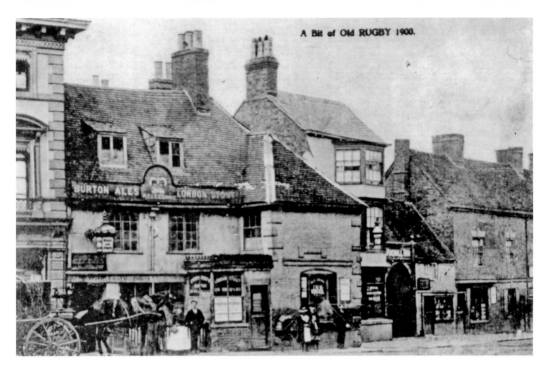

The Old Crown Inn

The Old Crown Inn stands in Market Place and dates back to the thirteenth century. Although the top photograph states 1900, the Millennium List suggests it was demolished in 1898. The building was replaced on the same site and reopened in 1903. The Windmill Inn, which is now known as the Rugby Tavern, remains much the same except for some extension work.

MOST RECENT NAME	PREVIOUS NAMES	ADDRESS	OPENED	CLOSED	STATUS	COMMENTS
RUGBY						
ADDISON ARMS		166 Lawford Rd.	1853	1857/62	Closed	Now a private house
ALEXANDRA ARMS		72 James St.	1883		Open	
AVON MILL INN	AVON INN	104 Newbold Rd.	1850		Open	
BADGER BAR		Bank St.	1990	C1995	Closed	Being rebuilt, Dec 1999
BEAR & RAGGED STAFF	BLACK BEAR	Market Place	16thC?	1801	Demolished	Site now main entrance to Clock Tower shopping centre
BEEHIVE		24 Union St.	1846	1985	Demolished	At opposite end of East Union St. from Royal Oak (2)
BLACK HORSE		14 Gas St.	C1855	1981	Closed	Was a hairdressers, now a private house
BLACK SWAN	SWAN, SWAN LANE INN	2 Chapel St.	Early 19thC?		Open	Probably built much earlier than the opening date
BLADE BONE		Lawford Rd.?	?	?	Demolished	Probably near cement works
BUTLER'S LEAP		Clifton Rd.	1997		Open	
CAFE NOIR	ROYAL WARWICKS	6 Little Church St.	1995		Open	Formerly Whittaker's wine merchants
CARLTON		130 Railway Terrace	1952		Open	
CHUMLEY'S		12 Bank St.	1997		Open	Formerly cinema and supermarket
CLIFTON INN		343 Clifton Rd.	1892		Open	Could be a rebuild of the Engineman's Home
YE OLDE COURTHOUSE	SARACENS HEAD (2)	18 North St.	1933		Open	Replaced Saracens Head (1) on same site
CROSS KEYS		2 Lawrence Sherriffe St.	1855	1862	Demolished	Site now occupied by It's a Gift
CROWN (1)		25 Market Place	13thC?	17thC?	Demolished	Replaced by Crown (2) on same site
CROWN (2)		25 Market Place	17thC?	1896	Demolished	Replaced by Crown (3) on same site
CROWN (3)		25 Market Place	1903		Open	
CROW PIE		Bilton Rd.	1957		Open	
DOG & GUN		15 Little Church St.	C1863	1969	Closed	Now the Ukrainian Club
DUN COW	BROWN COW, GRANT'S OLD MARINE STORES	29 Lawford Rd.	C1840	1922	Closed	Workers Union Club to 1970, then printers, now empty
ENGINE		1 Bridget St.	1855		Open	
ENGINEMAN'S HOME		1 Spoil Bank	C1870	C1890	Demolished	See Clifton Inn
FITCHEW & FIRKIN	BULL HOTEL, FIGHTING COCKS	26 Sheep St.	1720		Open	
FORESTERS ARMS		21 West St.	1868	1972	Demolished	Site now a petrol station on Corporation St.
FOX		24 Gas St.	C1863	1985	Closed	Now the Irish Club
GEORGE (1)	GEORGE & WHEATSHEAF, WHEATSHEAF	1 Market Place	1662	1846	Demolished	Replaced by George (2), see Royal George
GRAND HOTEL	RUGBY PRIVATE HOTEL	10 Albert St.	1882	1974	Demolished	Site now occupied by Kingsforth House
GREEN MAN		?	?	?	?	No information, just a mention in a newspaper
GRIFFIN		1 Kingsway	1957		Open	
HALF MOON (1)	LION & LAMB, HORSE & PANNIERS, EXCHEQUER, SOW GELDERS ARMS	Sheep St.	?	?	?	Existed in 1814
HALF MOON (2)		25 Lawford Rd.	C1850		Open	
HEN & CHICKENS		29 Sheep St.	C1700	1884	Demolished	Replaced by the Exchange on same site, see Oliver's
HOLLY BUSH (1)		1 New St.	1885	1929	Closed	Was Townsend's cycles, now empty
HOLLY BUSH (2)		Lawford Rd.	1929		Open	
HORSE & JOCKEY		6 Lawford Rd.	1840	1958	Demolished	Site now occupied by Bloxam Court, Corporation St.
IMPERIAL		165 Oxford St.	19thC		Open	Built as a private club
JOLLY ABBOT		241 Lwr. Hillmorton Rd.	1959		Open	Took the license from the New Inn, Hillmorton
KING'S HEAD	PEACOCK (1), NEPTUNE	17 Sheep St.	17thC	1869	Demolished	Site now occupied by Boots
LEGEND	GLOBE	125 Railway Terrace	1840		Open	

The Millennium List

I have included these fascinating lists as they record the history of the pubs and drinking houses over the last 100 years. It details the names of pubs that have flourished in the town and what happened to them eventually such as when renamed/refurbished, or even closed altogether.

THE MILLENNIUM LIST PT II

MOST RECENT NAME	PREVIOUS NAMES	ADDRESS	OPENED	CLOSED	STATUS	COMMENTS
RUGBY						
LONDON HOUSE (1)		6 Chapel St.	1868	C1900	Demolished	Stood to the front, at an angle, to London House (2)
LONDON HOUSE (2)		6 Chapel St.	C1900		Open	
MADISON'S	BROOKE'S, RICK'S PLACE, RETURN TO OZ, O'MALLEY'S, AUSTRALIAN ARMS, COACH & HORSES	46 Chapel St.	1840		Open	
MARKET REFRESHMENT ROOMS		Cattle Market	1897		Open	
MARLOWE'S	BLITZ, CENTRAL HOTEL, GRAZIER'S ARMS	Church St.	1835	?	Closed	Now Gas St. 2 nightclub
MERRY MINSTREL/ MR Q'S	RED LION (3)	21 Sheep St.	1926		Open	Replaced Red Lion (2) on same site
ODDFELLOW'S ARMS		16 Russell St.	C1855	C1861	Demolished	Site now covered by Clock Tower shopping centre
OLD OAK		Union St.	C1855	C1870	Demolished	Site now occupied by almshouses
OLIVER'S	EXCHANGE, ROYAL HOTEL	29 Sheep St.	1885		Open	Replaced Hen & Chickens on same site
O'NEILL'S IRISH BAR		16 Regent St.	1997		Open	Formerly Argos store
PADDOX	BARNABY'S, HEART OF OAK	360 Hillmorton Rd.	1936		Open	
PEACOCK (2)		North St.	Early 19thC	Mid 19thC	Demolished	Stood near Bingo Hall/ Crown House
PEACOCK (3)		1 Avon St.	C1860	1897	Closed	Now the Empire Club
PEACOCK (4)		69 Newbold Rd.	1897		Open	
PIG & TRUFFLE	LLOYD'S, LAWRENCE SHERRIFFE ARMS	49 Church St.	1833		Open	
PRINCE OF WALES		7 Drury Lane	1865		Open	
QUEEN'S HEAD		West St.	1837	1965	Demolished	Site now a car park, Corporation St./Elborow St.
RAGLAN ARMS	CRICKETER'S ARMS	50 Dunchurch Rd.	C1840		Open	
RED LION (1)		21 Sheep St.	16thC	1645	Demolished	Replaced by a private house
RED LION (2)	STANNARD'S WINE & SPIRIT VAULTS	21 Sheep St.	1840	1926	Demolished	Occupied two separate buildings on Merry Minstrel site
READ'S		Henry St.	1999		Open	Previously part of Bostrom's/Sam Robbins store
ROYAL GEORGE	ROYAL GEORGE & DRAGON, GEORGE (2)	1 Market Place	1848	1955	Demolished	Site now occupied by row of shops incl. H Samuels
ROYAL OAK (1)		Dunchurch St.	?	1846	Demolished	Occupied part of what are now St Maries church grounds
ROYAL OAK (2)		62 Dunchurch Rd.	Pre 1863		Open	Rebuilt 1903
ROYAL OAK (3)		233 Lawford Rd.	C1850	1960	Demolished	Replaced by Royal Oak (4) on same site
ROYAL OAK (4)		233 Lawford Rd.	1961		Open	
RUGBY TAVERN	WINDMILL	1 North St.	Pre 1792		Open	Originally built as a private house
SARACENS HEAD (1)		18 North St.	Pre 1830	1933	Demolished	Replaced by Saracens Head (2) on same site
SEVEN STARS		Albert Square	C1870		Open	
SHAKESPEARE		7 Queen St.	1835	1987	Closed	Derelict
SHOULDER OF MUTTON		4 High St.	Pre 1795	1899	Demolished	Site now occupied by Marks & Spencers
SPREAD EAGLE		Market Place	1508	1861	Closed	3/5 now the TSB, 2/5 demolished (site now Stokes)
SQUIRREL INN		33 Church St.	1869		Open	Converted from three old cottages
STAR (1)		Warwick St.	16thC	1870	Demolished	Thatched pub, replaced by Star (2) on same site.
STAR (2)		Warwick St.	1872	1977	Demolished	Site now occupied by pavement and clock
STATION REFRESHMENT ROOM		Midland Station	1885		Open	
THREE HORSESHOES	HORSESHOES	23 Sheep St.	18thC		Open	
VICTORIA		1 Lwr. Hillmorton Rd.	18thC		Open	
VOLUNTEER		Windmill Lane	1866	1867	Demolished	Site now covered by Clock Tower shopping centre
WHEELTAPPERS HOTEL	RAILWAY INN	123 Railway Terrace	1840		Open	
WHITE HART (1)		36 Sheep St.	15thC	1862	Demolished	Burnt down, replaced by White Hart (2) on same site
WHITE HART (2)		36 Sheep St.	1865	1873	Closed	Ground floor now Co-op electrical shop
WHITE HORSE		Whitehall Rd.	15thC	Early 19thC	Demolished	May have been a pub, no proof found
WHITE LION	TRAVELLERS REST	20 York Place	C1870	C1975	Demolished	Site now covered by the gyratory system
WILLIAM WEBB ELLIS	PAPILLON WINE BAR	22 Warwick St.	C1980		Open	Formerly an off license
WINEBARREL	BARREL	5 Market Place	C1880	1984	Closed	Shell only remains, McDonald's internals are all new
WOOLPACK INN		55 Union St.	1874	1979	Demolished	Site now occupied by almshouses
ZIGGY'S WINE BAR		65 Church St.	C1985	C1990	Closed	Now Tikash restaurant

Echo

Standing at the top of the Floral Steps was a statue aptly named 'Echo'. It was donated by the Rugby solicitor M. H. Worthington who, upon his death in 1943, had his ashes scattered in the park. The statue became affectionately known as 'Peter Pan'. The modern sculpture, standing in a floral display at the top of the newly designed floral steps, replaced the original design. The bottom photograph gives you an idea of how the approach to the steps looks now.

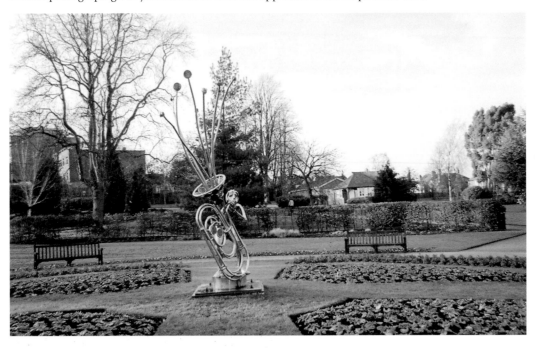

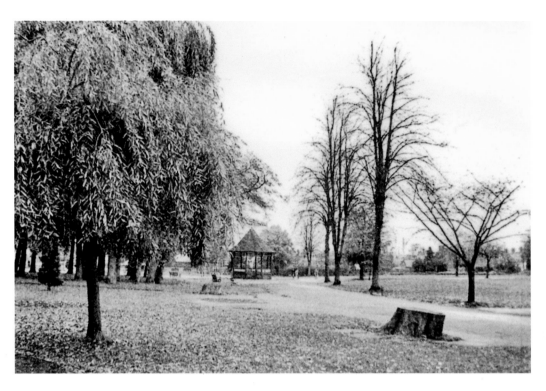

The Bandstand

The newly refurbished bandstand was erected by Fawcett's, a local cabinet making and building firm in 1910, back when Sunday band concerts were very popular and enjoyed by many. Alas, this six-sided bandstand is no longer in use for concerts, but still makes a delightful centre piece to Caldecote Park.

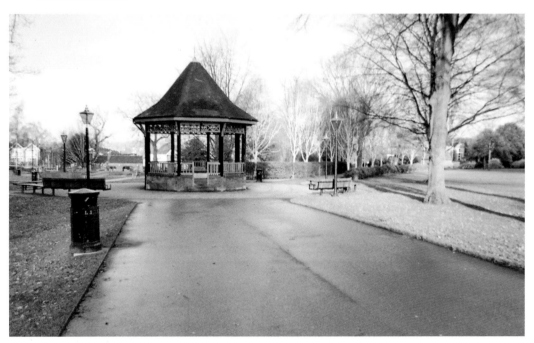

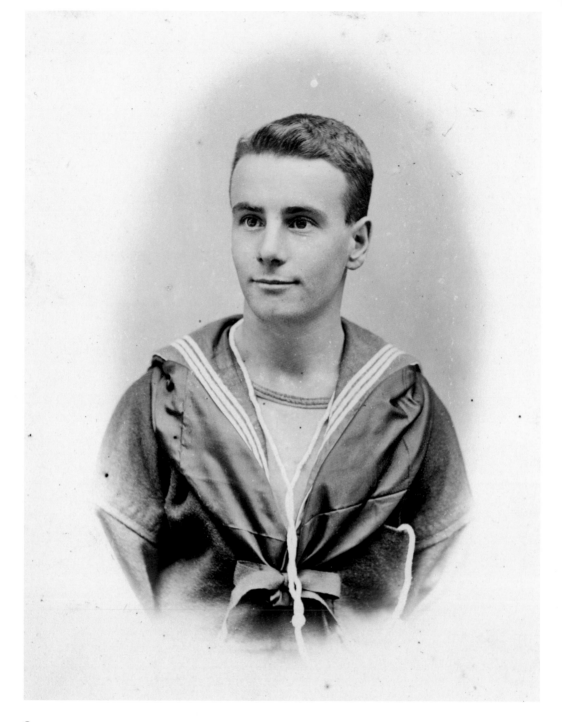

Sam

This lovely young man was among a bundle of old photographs I was given by a relative of someone who had just passed away in Rugby. I have included the photograph in the book in the slender hope that his family may see it. The note on the back of the postcard reads 'With love to Emily from Sam. 1 June 1898'.

54

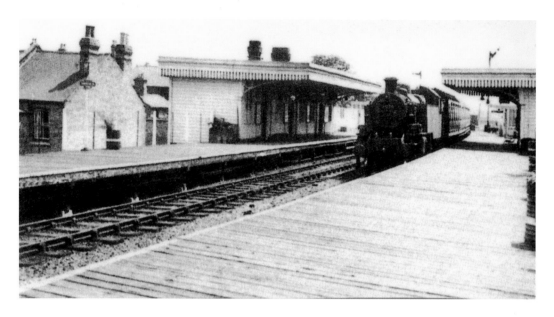

A Trip to Rugby

The top photograph shows the arrival of the locomotive that only ran to Rugby on Wednesdays, at Milverton Station. The wooden platform, signals and houses – which were tied houses for railway workers – give the photograph the charisma of days gone by, when a trip in a train was something wonderful to look forward to. The happy faces in the bottom photograph have just returned from a day trip to Rugby on the LMS line. From left to right we see Gillian Cox, and her father Jack Cox holding her brother Roland. Standing next to him are Elsie Dawson and her son Peter, while Mrs Molly Cox stands on the right.

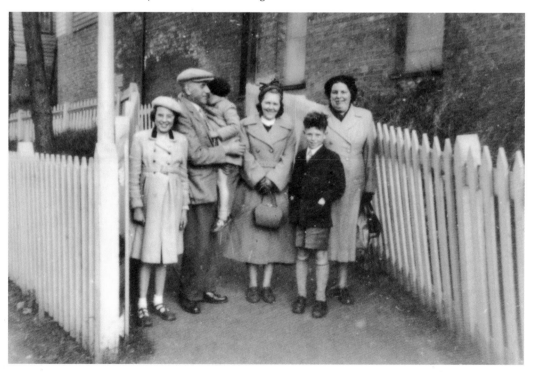

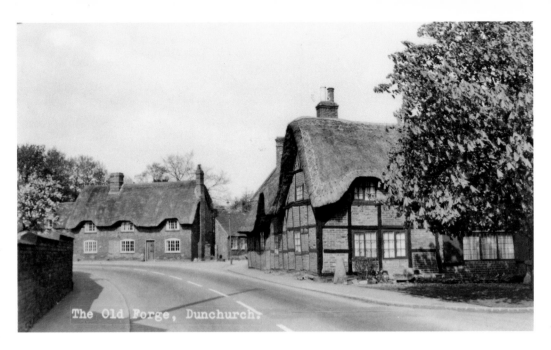

The Old Forge, Dunchurch.

Old Forge at Dunchurch

Most old villages had a forge and Dunchurch was no exception. Here we see the old forge as it used to look, and how it looks now having travelled through time. It still has its thatched roof but oh dear, the traffic!

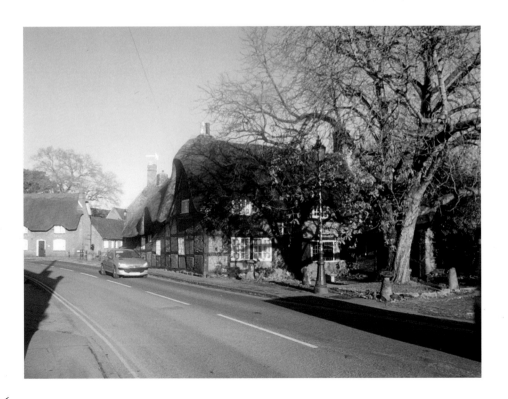

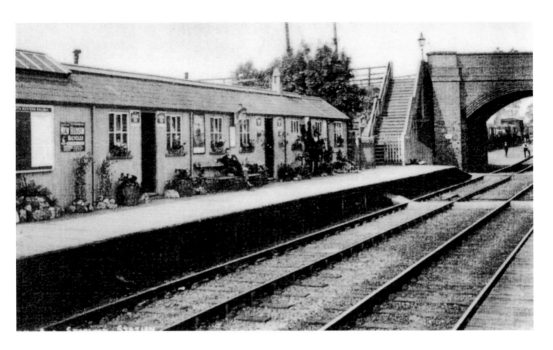

Frankton Station

Here we see the Napton & Stockton Railway Line, which was opened in 1895. Long since closed, all that remains of the station now is the white building in the bottom photograph, which is now in the garden of a large house that stands on the old site. The man in the picture up above is Mr E. B. Law.

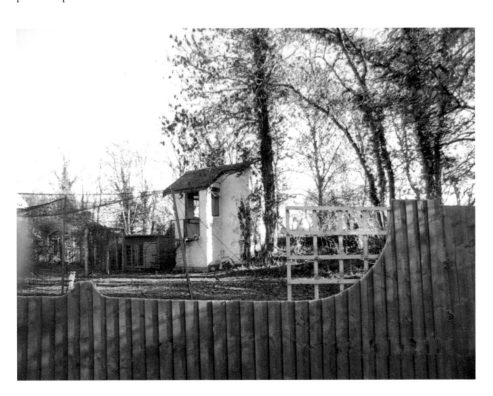

A Brief Look Around
The top postcard is of the village smithy in Dunchurch. Below, we have a look back through time to Birdingbury station, alas no more.

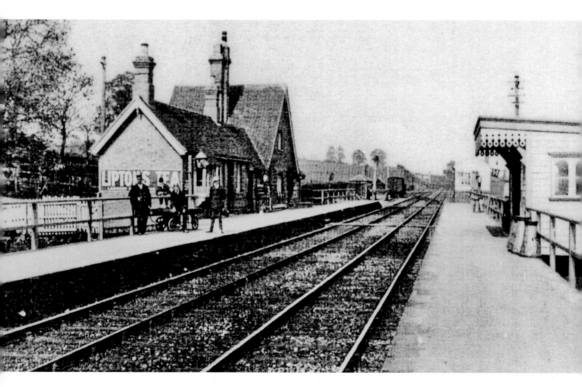

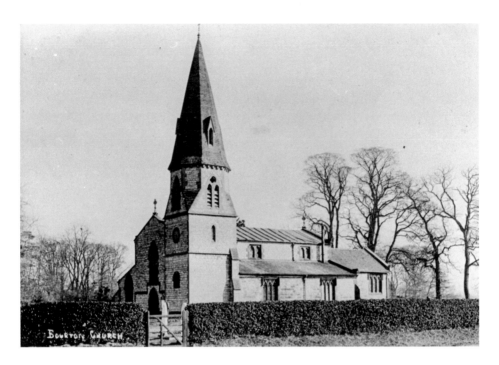

St Peter

The old church of St Peter can be seen in Bourton-on-Dunsmore, which is 5½ miles from Rugby. The church underwent two renovations in 1842 and 1850. Inside the church is an uncommon medieval font with a massive octagonal bowl. Alas, the stem and base have gone! Another old feature of the church is the oak 'Parson and Clerk' pulpit and desk. The panels of the pulpit date back to 1607.

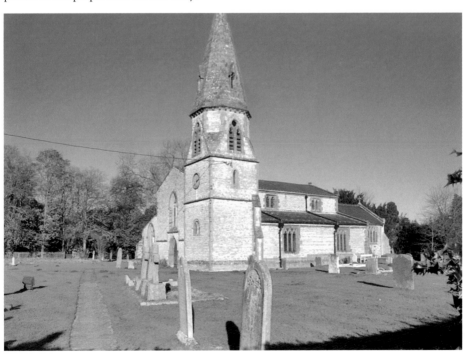

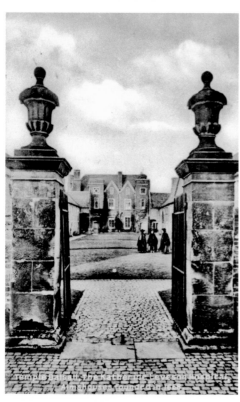

Temple Balsall, the Katherine Leveson Hospital
Almshouses, founded in 1868

Temple Balsall

Two lovely old postcards of Temple Balsall.
The top picture is of the Katherine Leveson
Hospital Almshouses, founded in 1868, while
the bottom picture shows the inside of St
Mary's church and its delightful stained glass
window.

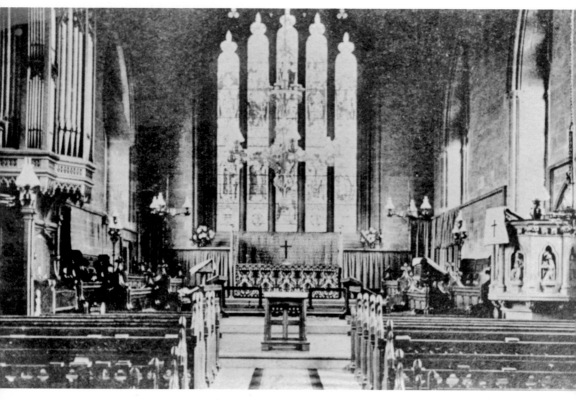

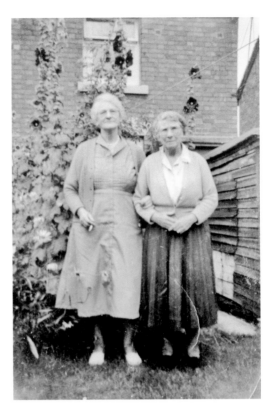

A Family Through Time

These lovely ladies in the 1950s are Ethel and May Bagnall. The bride is Marjorie Bagnall, May's daughter, who married Mr John Simpson. They were to have one son, Jonathon. Sadly they are no longer with us.

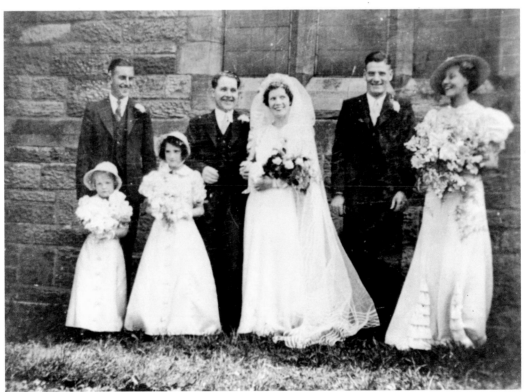

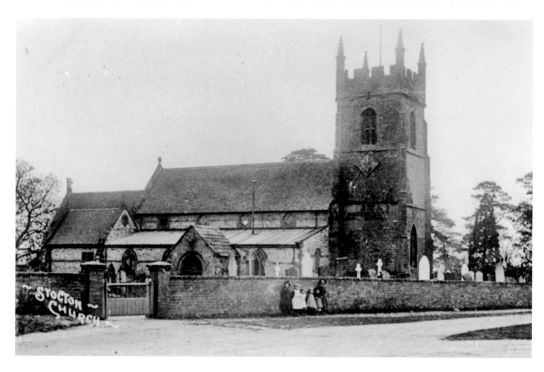

Stockton Church

I discovered this beautiful old church at Stockton by the village green. St Michael's church has undergone many alterations over the years. The nave and north aisle were rebuilt in 1863. The fifteenth-century west tower is embattled and pinnacled. The church register dates back to 1560. Noted for the Blue Lias lime works, it has a huge boulder of great geological interest.

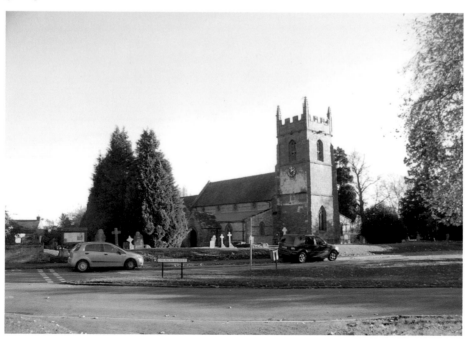

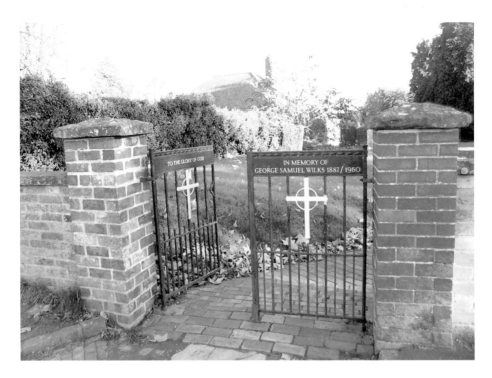

George Samuel Wilks

These lovely old gates are the entrance gates to St Michael's church in Stockton. The lettering on the gates reads 'To the glory of God. In memory of George Samuel Wilks 1887/1960'. Walk through the gates and you are greeted, after walking through an archway of yew trees, by the entrance to the church.

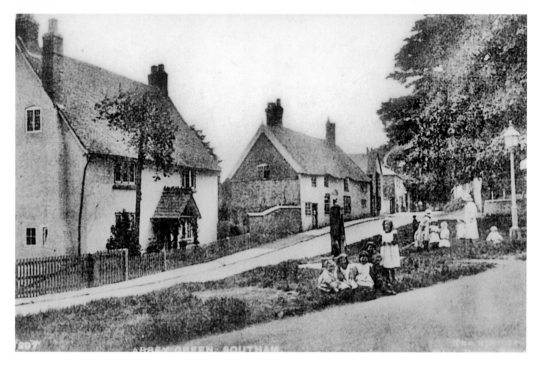

Abbey Green, Southam
Abbey Green, Southam. Abbey House nearby had associations with the Priory of Coventry. In the garden are some very old, protected yew trees.

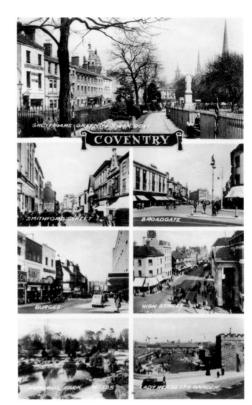

Random Views

No book would be complete without a random view of Rugby's neighbour, Coventry. I always feel it's nice to look back through time and see how things used to be.

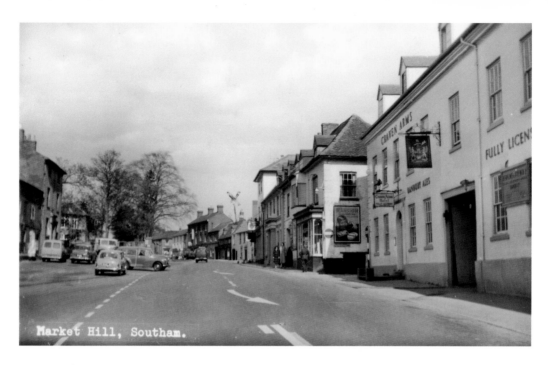

Market Hill, Southam.

Southam

An act was passed in 1846 for a railway to be built from Oxford to Rugby via Southam. Alas, the northern section from Fenny Compton was never completed. The building in the bottom photograph was the Craven Arms, which in its heyday was a very busy coaching halt, with eight regular coaches calling there.

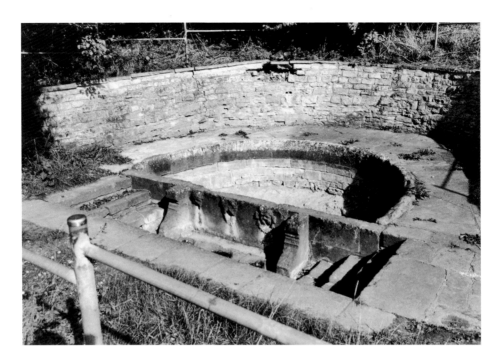

The Holy Well

The well was first mentioned in AD 998 and is listed grade two. The water from the well is intensely cold and came to be regarded as a cure for eye ailments. Arthur Mee wrote in *Warwickshire*, 'Southam has a Holy Well that never freezes and a street that always pleases.' It is not the easiest place to find, but if you don't mind a walk it is well worth a visit.

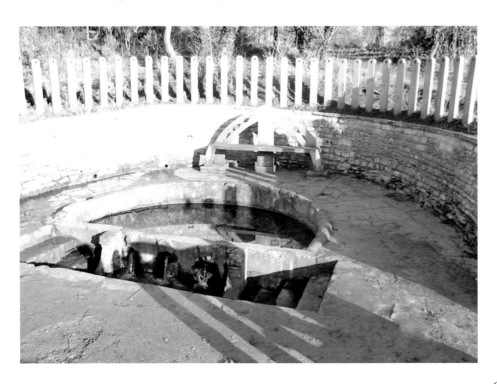

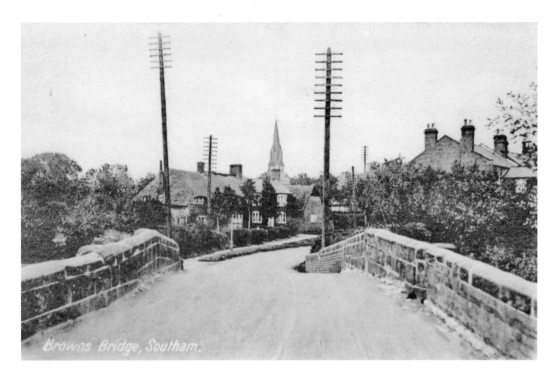

Browns Bridge, Southam.

Brown's Bridge

Thought to be the actual site of the ducking stool, notorious for the punishment of women who were 'scalds' or 'disorderly'. Originally, the stool stood on the right-hand corner of the turn down to the Welsh Road east of Pendycke street. The ducking stool or 'cuckstool' was used up to the early 1850s.

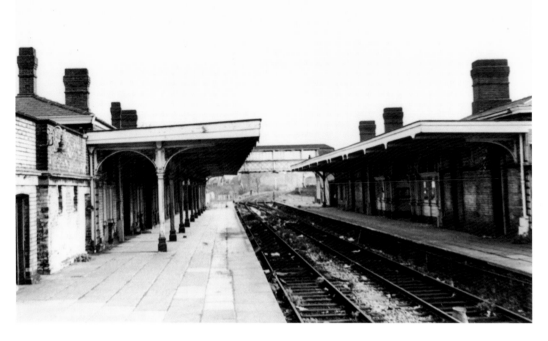

Sad Farewell

Having enjoyed some beautiful train rides on the Rugby line, visiting Rugby and godparents at Long Itchington, I was very sad to see the arrival of the last train from Rugby at Leamington Spa Station. It was a Saturday and, as we did not work on a Saturday, my husband and I went along to say our goodbyes on 13 June 1959.

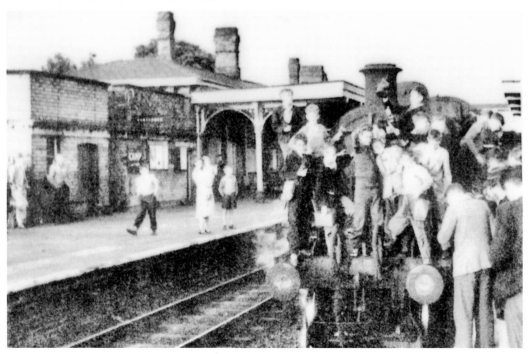

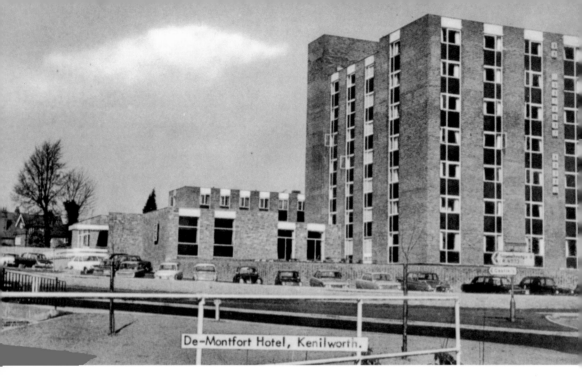

De-Montfort Hotel, Kenilworth.

De Montfort Hotel
Two contrasting pictures of the De Montfort Hotel in Kenworth.

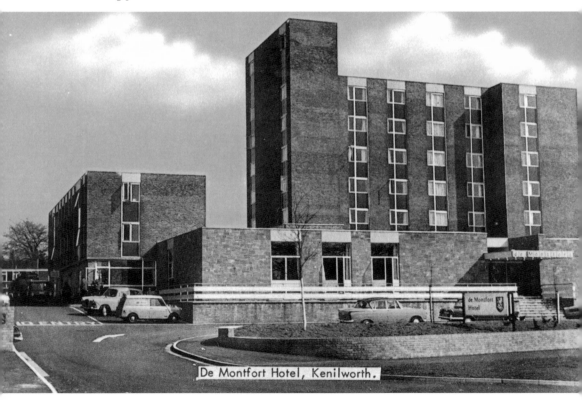

De Montfort Hotel, Kenilworth.

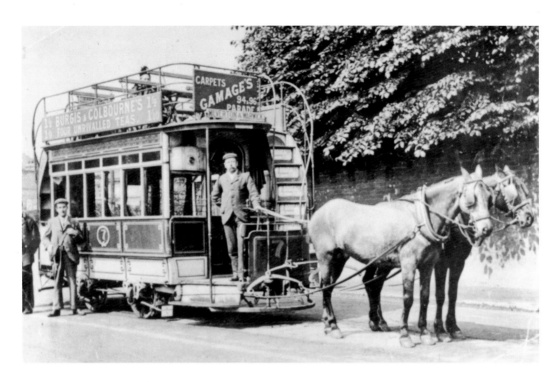

Transport Through Time

These two trams are a wonderful example of transport through time. The top photograph shows the horse-drawn tram that was replaced by the electric tram in the bottom photograph. These two lovely old pictures were taken in Royal Leamington Spa.

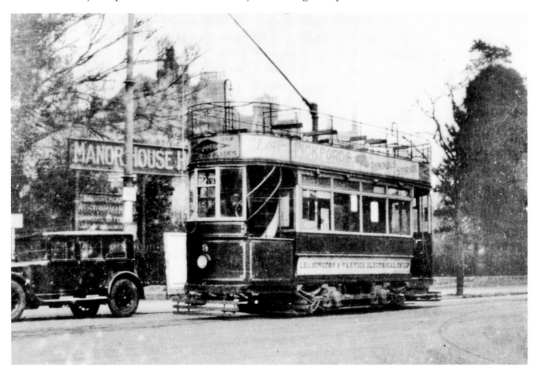

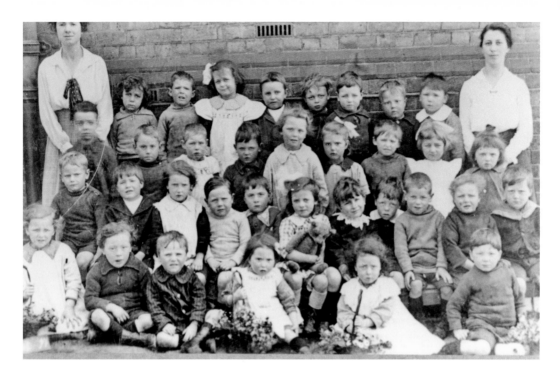

Westgate School Warwick

Taken around 1920, we see a group of pupils who attended the school at this time. Like many old photographs, putting names to faces can be difficult. I know Dia Vaughan, Lillian Marlow and Barbara Potter are in the photograph, but exactly which name belongs to which face I don't know. In the bottom photograph we see the school as it appears today.

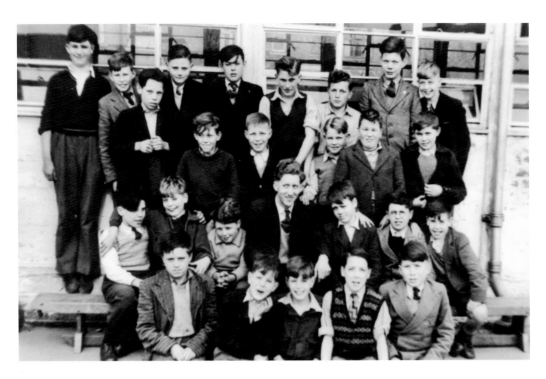

Stoke Junior, Coventry

Another peep into the past. This time it is Stoke Junior school in Coventry. The little boy fourth from the left is Robert Jones. The picture was taken in the 1940s. The bottom photograph shows the school as it looks today.

Queen Eleanor Cross, Northampton

TOWN HALL, NORTHAMPTON

Northampton
Two postcard views of Northampton.

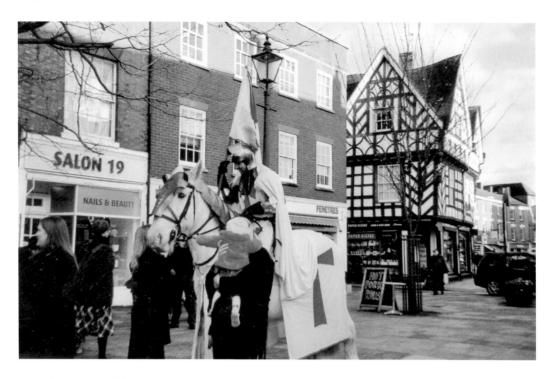

Around and About

This says it all for me – I came upon the knight in Warwick, while out photographing for the book. He was promoting an art exhibition at Warwick museum. The little girl had fallen in love with the horse and wanted to stroke it. What better way to depict through time than this? Below, taken from the bottom of the newly vamped Floral Steps and shows the park looking towards the entrance.

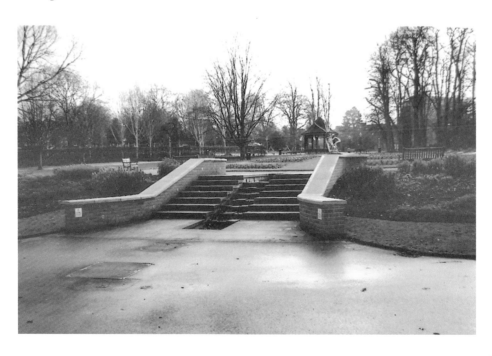

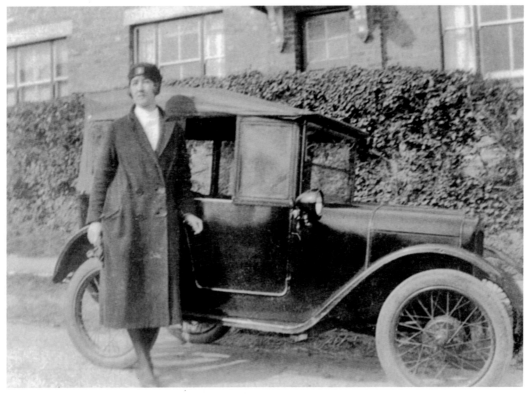

Doctor's Coupe
Here we see a delightful picture of an Austin 7, which was affectionately known as the Doctor's Coupe. The lady standing by the car was Nurse Muriel Hartshorne, a lady of great commitment. District Nurses were always available to give care and attention when needed. The bottom picture shows Lily Pugh, née Manton. She was the cousin of Emily K. Clark and the mother of Edna Pugh of Solihull. The photograph is dated 1927.

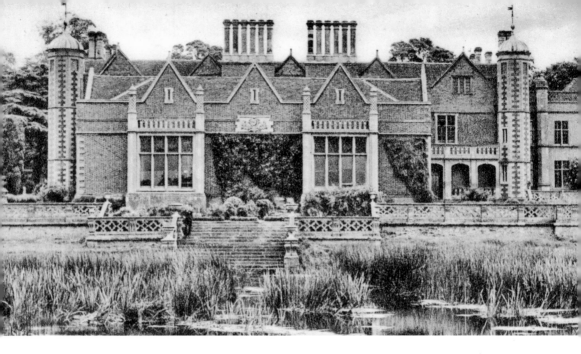

The Neighbours

The top photograph is of Charlecote House and Terrace. The bottom postcard is of the inside of Anne Hathaway's cottage. The early days of coloured postcards still hold a certain beauty about them.

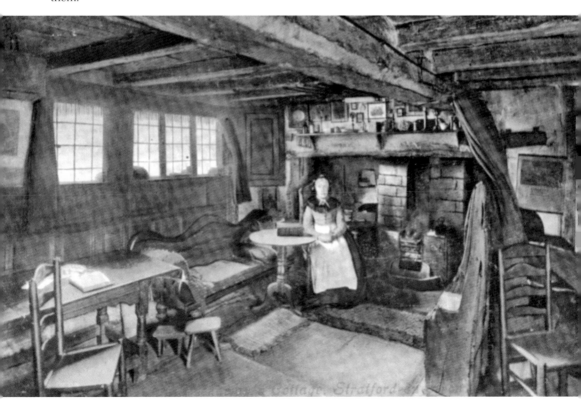

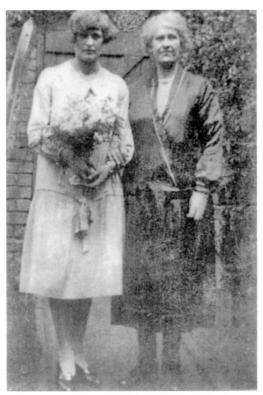

Family Through Time

As you know, I like to include a family through time, and here we see Lillian Shepherd and her mother in the late 1920s. She married local boy Tom Cox, and in the photograph we see the pair celebrating their golden wedding anniversary. The couple were to have no children and sadly both have passed away now.

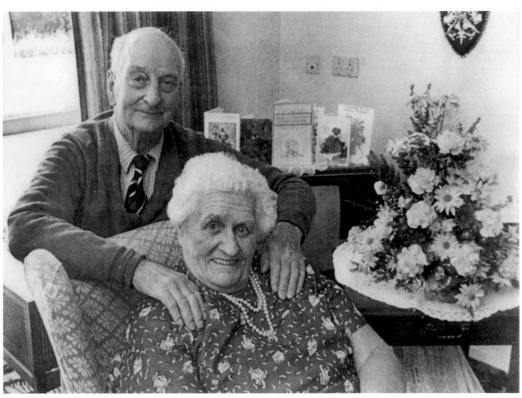

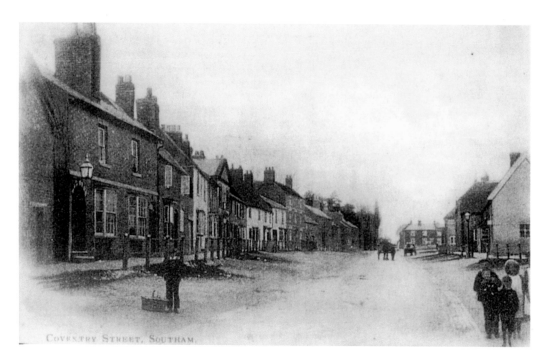

COVENTRY STREET, SOUTHAM.

As We Were

Two old pictures of Southam – the top picture shows Coventry Street and the bottom a rustic bridge! On the back of this postcard is simply written 'Southam'.

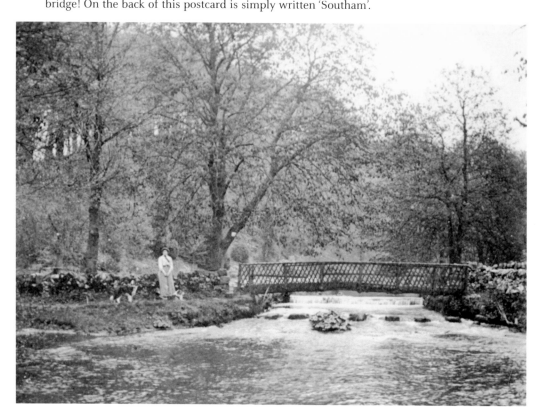

Like Father Like Son
In the top picture we see Walter Goode, a cobbler by profession, who ran his business in Royal Leamington Spa. Through time, his son Stan Goode continued the family tradition by becoming a successful cobbler himself. The shop in Warwick Street is no longer in business repairing shoes, as both father and son are no longer with us.

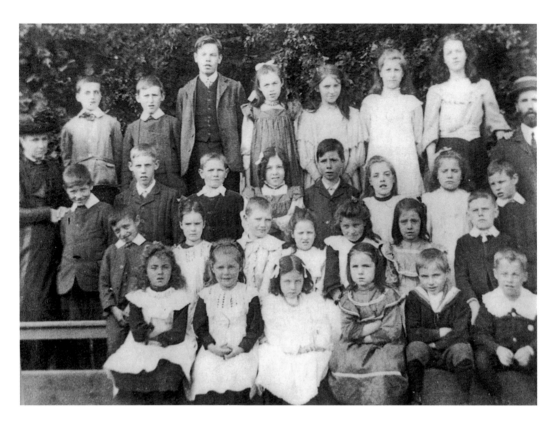

Wolverton Primary School

The pupils of Wolverton Primary school are seen here with their Headmaster, Mr W. Smith. My Father was a pupil at this school and he said if any pupil had a cough they would be given a piece of liquorice to suck. Needless to say, there was a lot of coughing at the school! The school is still up and running in 2011.

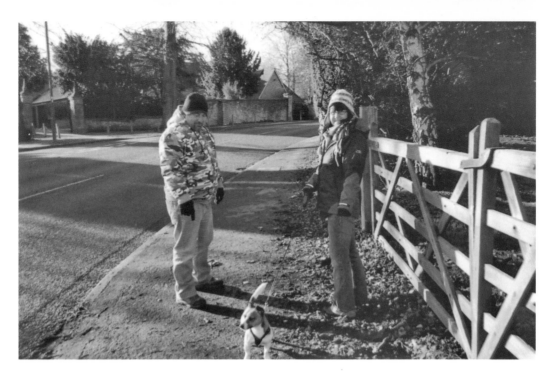

Different Views

Above, while I was taking photographs for the book on a rather frosty Sunday morning, I came across Mr and Mrs Macavoy and Danny the dog. They were like a tonic – the couple were very friendly and little Danny affectionate. They just had to be in the book! In 1851, the Leamington & North Western Railway Avenue Road station was opened. The photograph below for the train buffs was the 2483 Inter City express, which was standing in the station. Alas, the Avenue station met its demise on 23 January 1965 and is now a long-stay car park for train users.

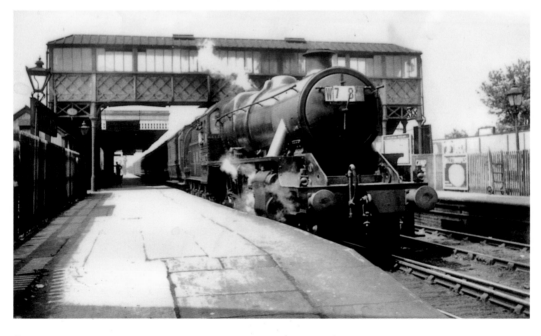

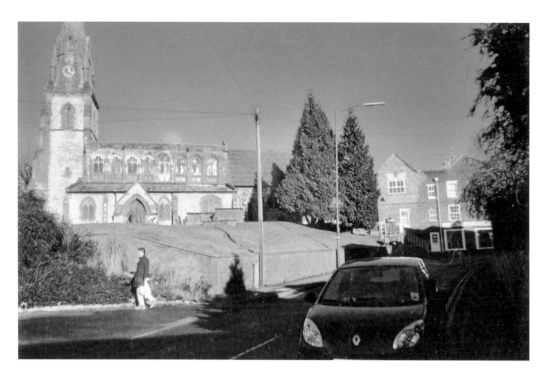

Church of St James

The original church of St James existed in 1220 and was replaced in the fourteenth century by the present church, which is in the perpendicular style. The list of rectors in the church goes back to 1296. The earliest known rector was Mr Henry in 1248.

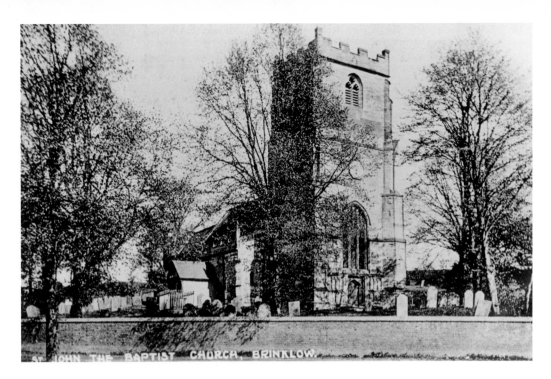

ST JOHN THE BAPTIST CHURCH, BRINKLOW.

Brinklow

Brinklow is a large village lying just 5½ miles north-west of Rugby. The church register of St John the Baptist, in Brinklow, dates back to 1588, while baptisms, burials and marriages date back to 1574. The interior of the church has an extraordinary rise of about eight feet from west to east.

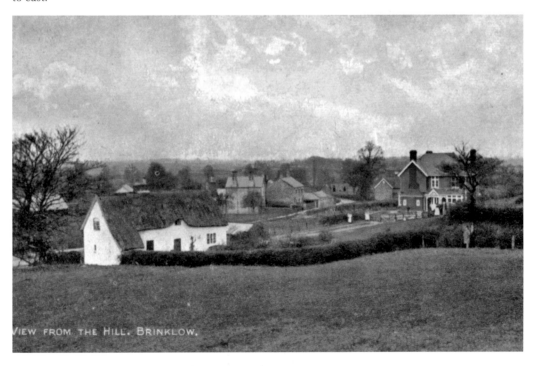

VIEW FROM THE HILL. BRINKLOW.

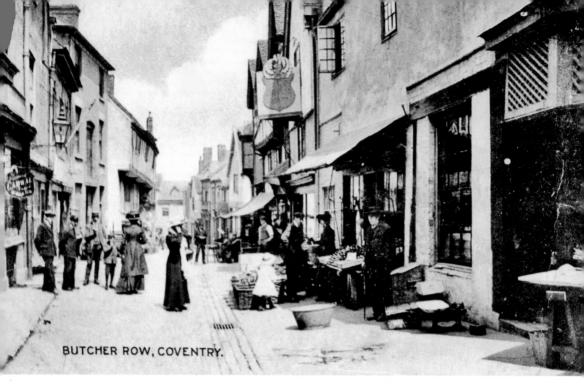

BUTCHER ROW, COVENTRY.

Butcher's Row

I love the charisma of these old postcards of Butcher's Row in Coventry. Not only do they give you a glimpse of the past, but they offer a fine example of how colour has developed over the years.

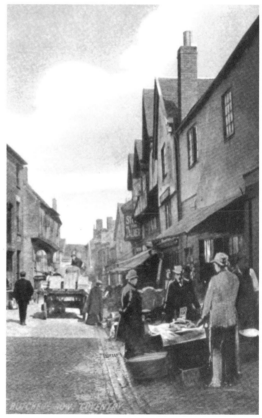

BUTCHER ROW, COVENTRY.

Mr Dia Tanner
Sitting on the grass taking
a rest on a charabanc trip
we see Mr Dia Tanner. In
the photograph below we
see the lady on the left
with her friend, who was
to become his wife. They
had a daughter, Jane.

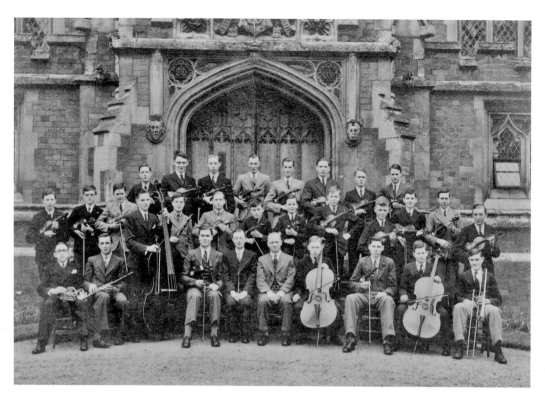

College and Market

The orchestra of Leamington Boys' College at the entrance to the college in the early 1940s. Sadly, the school is now closed and the beautiful old building is now in the hands of builders. Below, the market as it is seen today. Gone are the mud under foot and the puddles. If the man on the right looks familiar it's my husband.

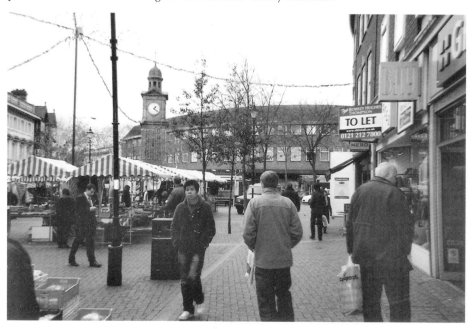

Princess Margaret

Here we see Princess Margaret leaving Sherbourne Church. A friend of the Lucys, who lived in Sherbourne, her Highness was a frequent visitor to the area. In the bottom picture we see Crick Church.

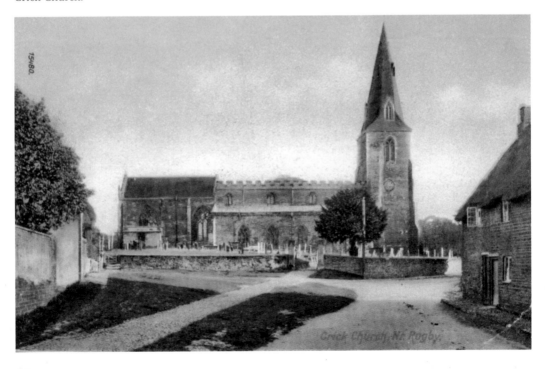

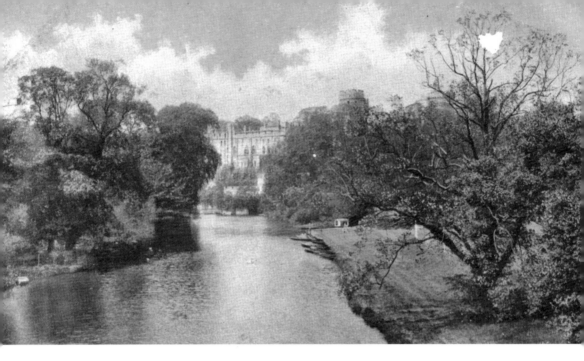

River Avon
The castle in Warwick, taken from the bridge. Even with these two pictures you can see how the area has changed over the course of the years.

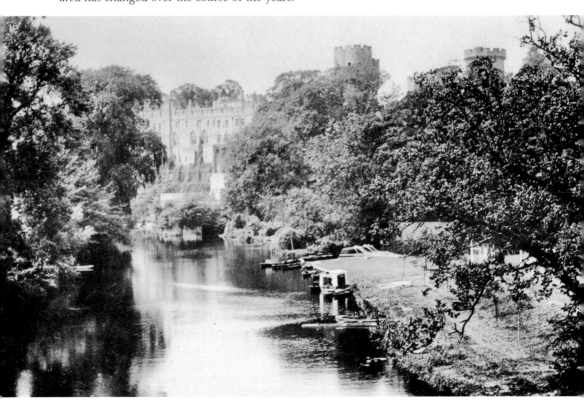

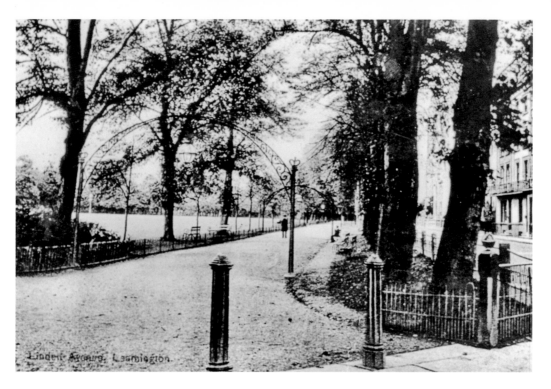

Leafy Leamington Gardens

I have included these two pictures to show Leamington Gardens how they used to look years ago. The church tower in the background is St Peter's. A very different picture shows the trees felled, railings disappeared and all of the flower beds gone.

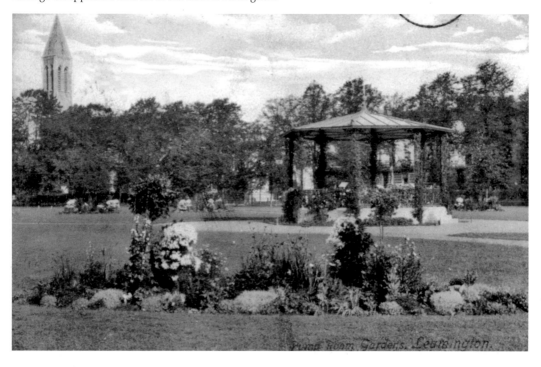

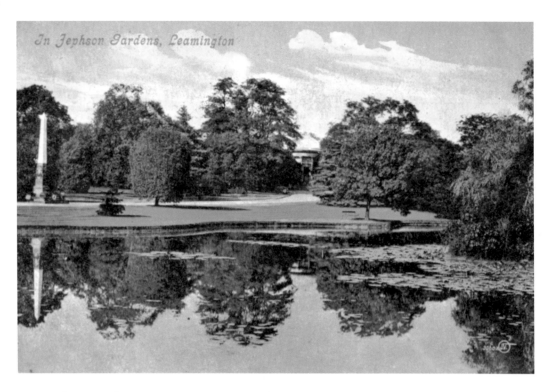

In Jephson Gardens, Leamington

Jephson Gardens

Two lovely views of the Jephson Gardens. The lake now has two fountains and the plain grass is covered with bedded plants, which always laid the town in good stead in Britain in Bloom.

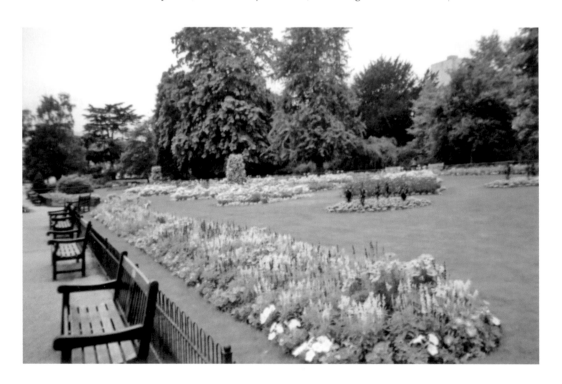

Old Warwick

The top postcard is of Mill Street, Warwick, which skirts the castle wall. The old Roman bridge, in its heyday, joined Bridge End to the town at the bottom of Mill Street.

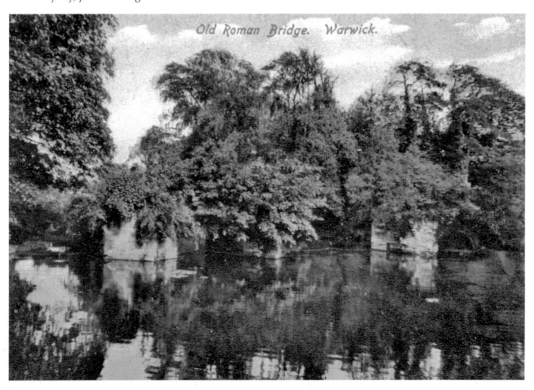

Old Roman Bridge. Warwick.

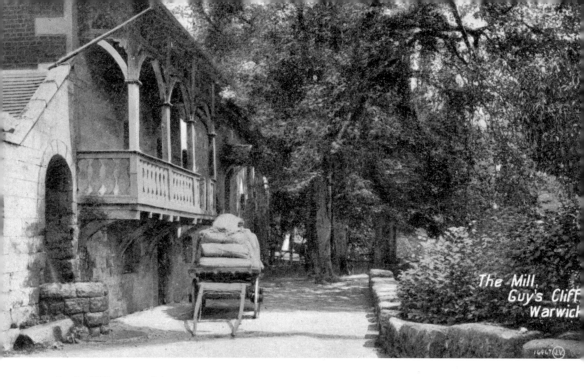

The Mill,
Guy's Cliff,
Warwick

Guy's Cliffe, Warwick
The Lovers' Seat by the old mill at Guy's Cliffe, Warwick, and a tranquil shot of the lovely old mill itself.

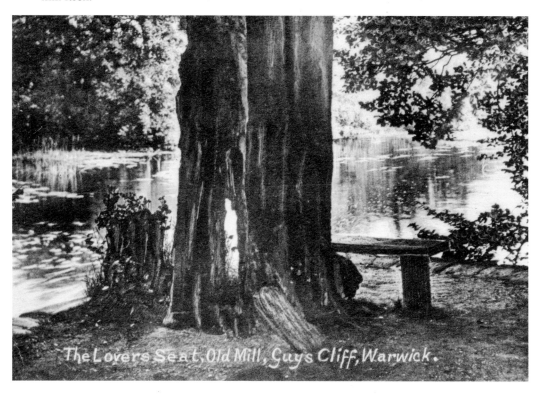

The Lovers Seat, Old Mill, Guys Cliff, Warwick.

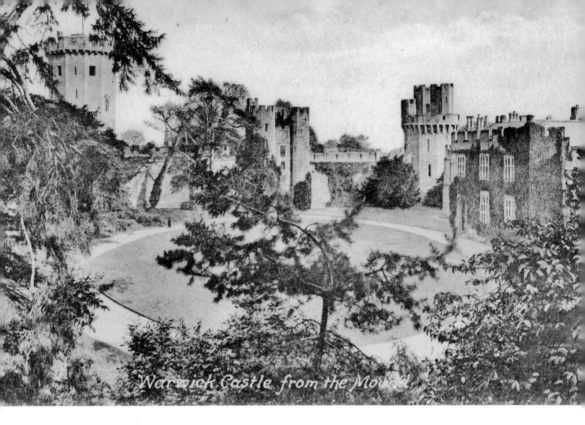

Warwick Castle from the Mound

Warwick Castle

Two contrasting views of the castle: one showing the view from the mount and the other a rather cold-looking castle wall.

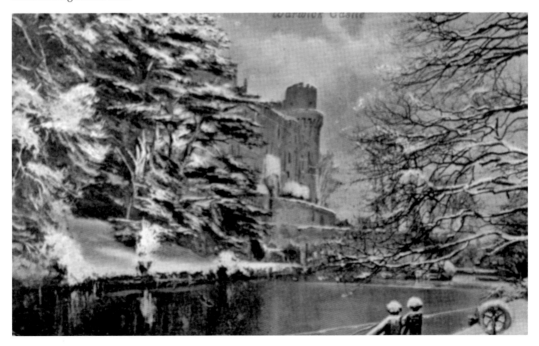

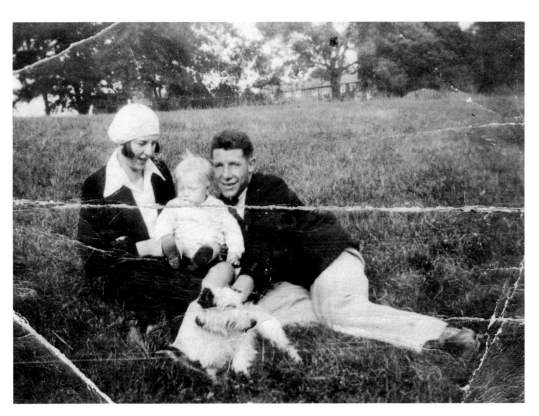

A Family Affair

Mrs Hilda Guerney, baby and husband, taking a trip into the country. Hilda's maiden name was Wells. Born in Rugby, Mr Wells, her father, kept cart horses by the Crow Pie pub. The young lady in the bottom photograph is her daughter-in-law, Margaret, who was married to her son Norman, taken in 1955.

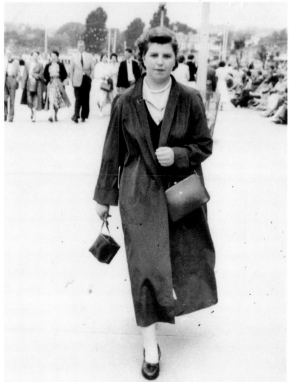

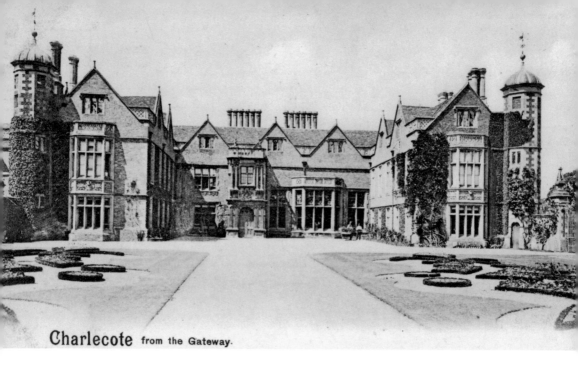

Charlecote from the Gateway.

Charlecote

Two lovely postcard views of Charlecote park. The top picture is of Charlecote house and the bottom is of the impressive park gates.

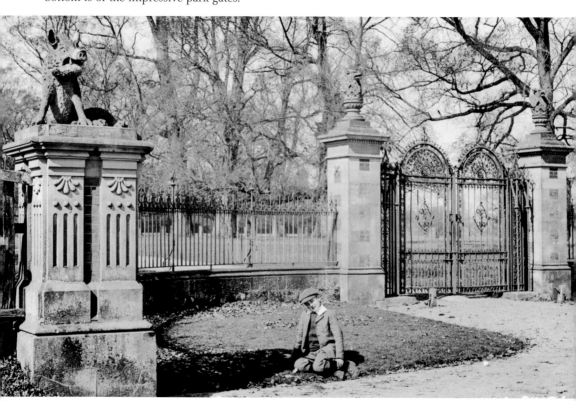